Dear You:

This is a personal movie, sound
track out of my own past, 95 true
photo images I stopped out of time.

You could make your own paper
movie, from that box of snapshots,
poems, diaries and old letters.
But this one is mine. My hope is
you find in it some bread and wine
for your own journey.

Come walk with me awhile. We can
be friends of the road. We could
even be lovers, so intimate that
for a brief hour you'll see the
world through my eyes.

Lou Stoumen

A Hand Press Book
published by
CELESTIAL ARTS
Millbrae, California

LOU STOUMEN

CAN'T ARGUE WITH SUNRISE

A PAPER MOVIE®

for my daughters

TOBY
TATIANA

First printing September 1975. Manufactured in the
United States of America by Celestial Arts, Millbrae,
California. Designed by Michael Glen at Hand Press,
Los Angeles, California.

Thanks to the Regents, faculty, students and
supporting taxpayers of the University of
California. An early experimental version
of this book was exhibited at UCLA Art Gallery,
hung as a walled movie under title *Dream of Islands*.

Library of Congress Cataloging in Publication Data

Stoumen, Louis Clyde
 Can't argue with sunrise / a paper movie

 "A Hand Press book"
 1. Photography, Artistic. 2. Photography, Doc-
umentary. 3. Poems. I. Title
TR654.S76 791.43'092'4 75-262
ISBN 0-89087-052-7
ISBN 0-89087-050-9 pbk.

THE SOUND TRACK

ONE
DREAM OF ISLANDS

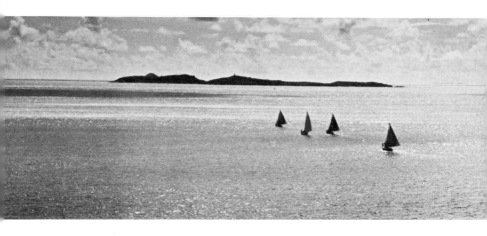

drunk at noon

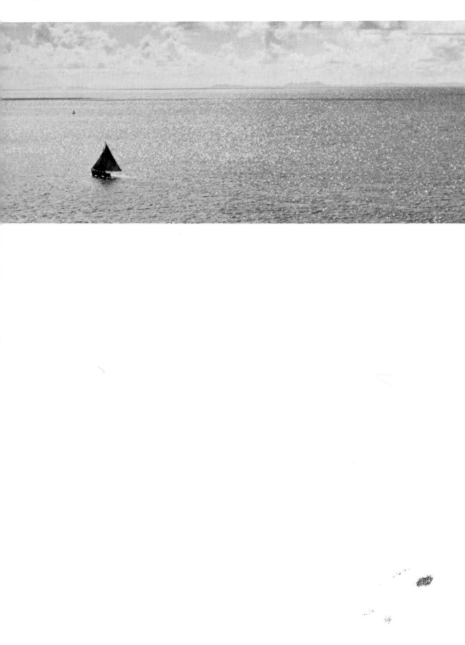

WHEN I WAS A BOY

in a Pennsylvania farm town

half a century ago

I dreamed of far green islands.

This large man writing

was that child

and contains him still.

I dreamed of manhood.

I wanted wheels sail wings

the world.

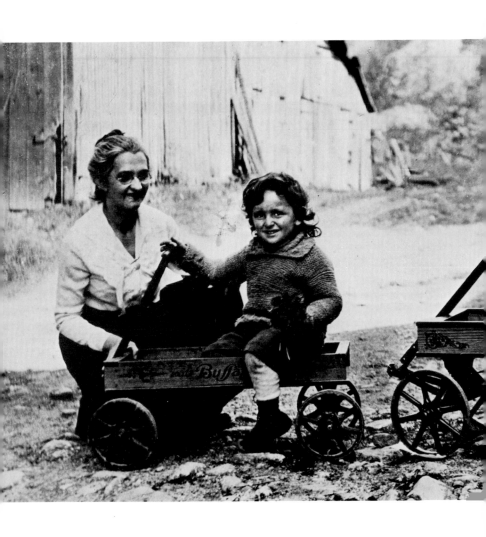

My father was a doctor in Springtown Pa.

He drove his Ford through the cornfields.

He lanced boils

delivered babies

cut out tonsils

told compassionate lies about cancer.

He often got paid in sausages and eggs.

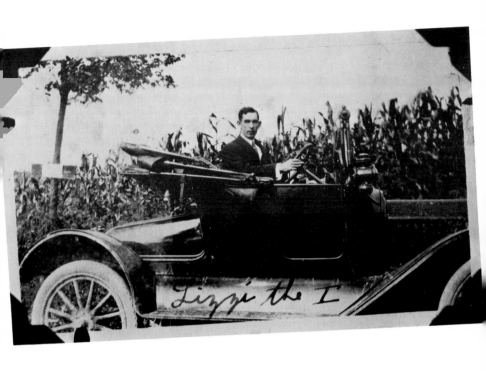

Lizzie the I

It was a marriage of strangers

arranged by wise Aunt Elizabeth.

Name and street number in hand

Sam Stoumen took the Pennsylvania Railroad

to Youngstown Ohio

where Sarah Grobstein lived

and carried her off

to be a country doctor's wife.

Mother gave piano lessons

to neighbor children

helped run the Doctor's Office

cried some

took me to the Philadelphia art museum

when I was six.

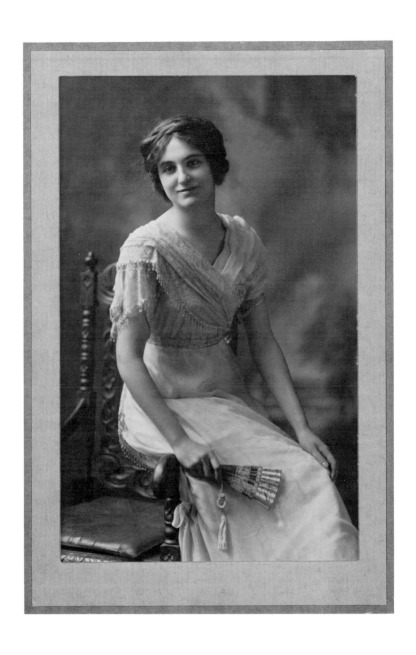

My father was a humanitarian.

He did free surgery

for thousands of patients.

He voted straight Democrat

taught brother Bob and me

to be for the Underdog

which he never defined.

After we moved to Bethlehem Pennsylvania

he once set up as a boxing promoter

brought in lightweight champion Benny Leonard.

But the Lehigh Valley Club hired an aging bum

to fight Benny.

Dad's score was debt

and a pair of autographed gloves.

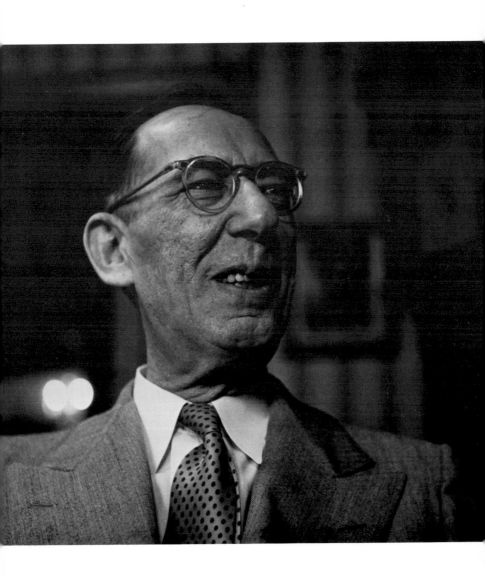

During the depression
we lost our home to the bank
moved to a rented house down the street.

Fourteen million Americans
couldn't find jobs those days.
Chicago cops massacred steel workers
bullets in their backs.

I remember President Hoover's fat face
in the newsreel
telling the people *Be Patient.*
I remember President Roosevelt on the radio
All We Have To Fear Is Fear Itself.

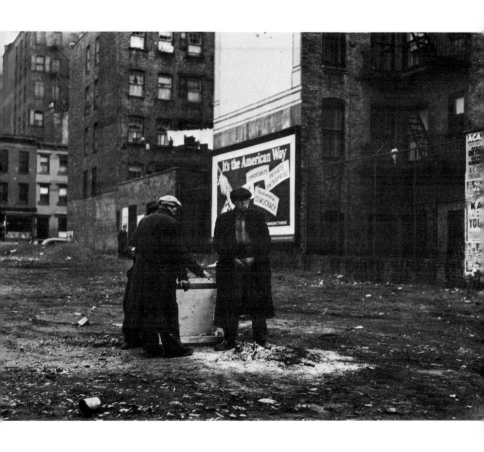

Those days before the pill
practically none of the young girls would.
There was traffic to the whores
of Reading and Philadelphia.

My old Liberty High School friends
got themselves cars and steady jobs
if they could find them those hard years
while I hit the road.
They married soft eager girls, and ambitious boys
while I lusted after strangers.

But I set foot at last
on five continents
and a hundred islands.

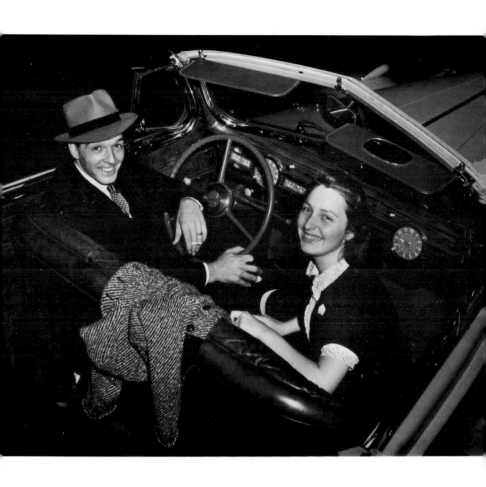

The islands were green.

Each had its own warm breath and heartbeat.

Their names were music.

Tortola! Ceylon! Cuba!

Puerto Rico! Haiti! Jamaica!

Mona! Madagascar! Zanzibar!

I've seen their palm forests

wake in the trade winds

lithe girls shaking out

their tousled morning hair.

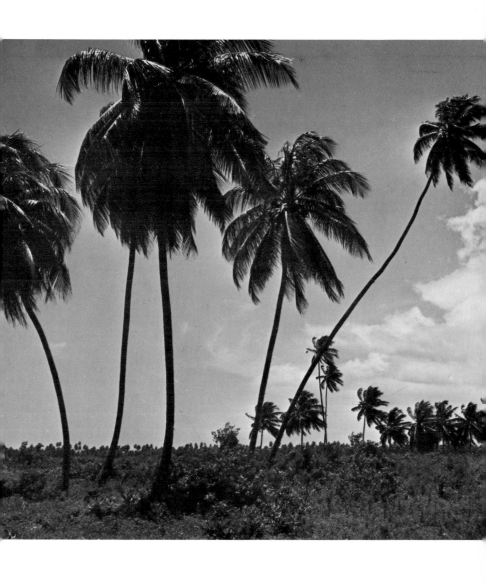

I was advance guard then
of the idiot Tourist
bigboned Kodaked
soaking up rum and sunshine and nooky.

There weren't many of us yankee visitors
those days before the war
only a few businessmen lawyers priests soldiers.
Conrad Hilton and the CIA
hadn't discovered America yet.

One Christmas day
out of film
I lay drunk at noon in a cane field
passing the rum bottle with sugar workers
singing *aguinaldos* to welcome the Christ child.

Toma, Luis! Drink!

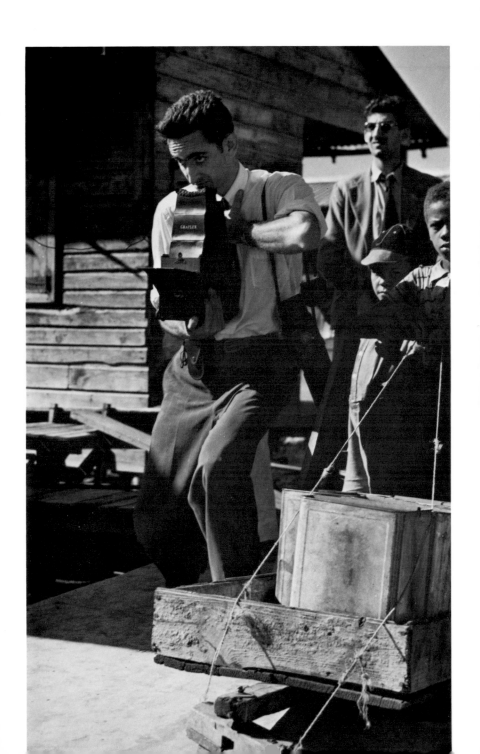

Made my first movie in Puerto Rico

a documentary on children.

Puerto Rico is a Paradise.

My camera eye found in it also a Hell.

Listen

do you hear the tubercular cough

of the unemployed sugar worker?

the sobbing of the tired pregnant-again mother?

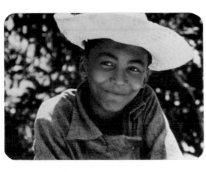
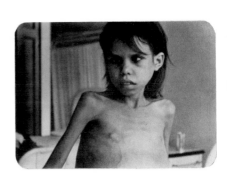
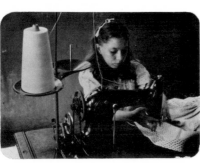
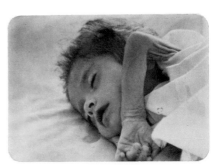
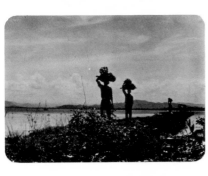
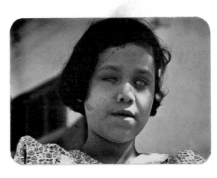
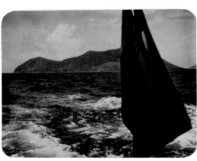
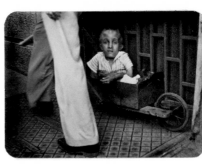

Hello boy. *Que tal?*
I'm glad to meet your eyes.
I think you look crucified
there against the wood of your home
boy Jesus.

I'm sorry about your baby brother.
You found him yes I know
just before this picture was made
fallen from the door stoop
drowned in six inches of muddy water.

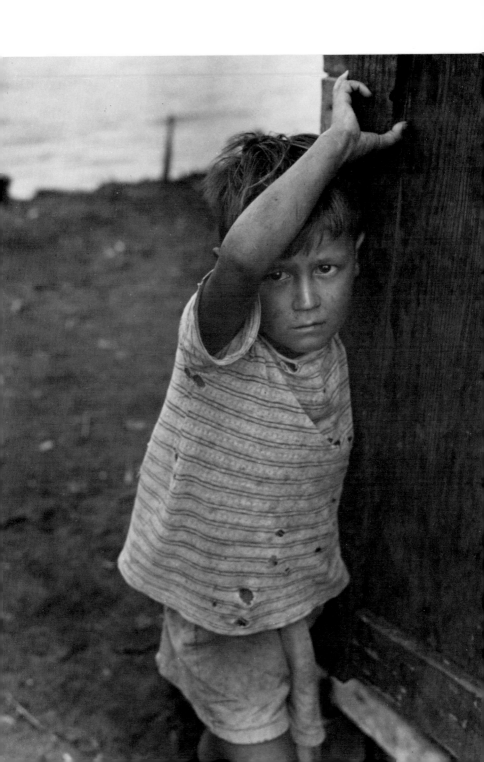

My camera eye looked in the face of yaws
malaria filiarisis granuloma.
I dined with lepers on St. Croix.
At a hospital in Santurce
I met a girl sick with amoebic dysentery.
I watched her die.

I lived three years in those islands
a thousand days of green and blue and sungold.
Then I'd enough of lyric beaches
and the people's hunger.
My heart hurt.

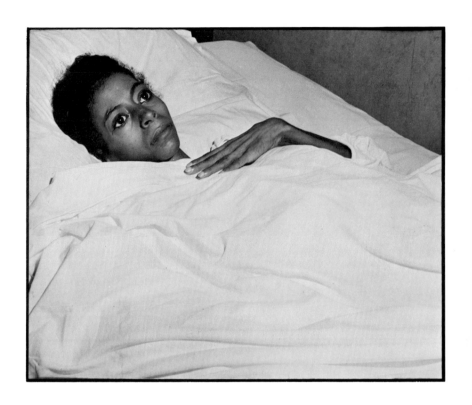

There was one thing more.

Darker.

Older.

You could sense it out in the oldest churches.

In the cane fields it was underfoot.

In the rain forests you could hear sighs.

Each island was in secret mourning.

For its Indians!

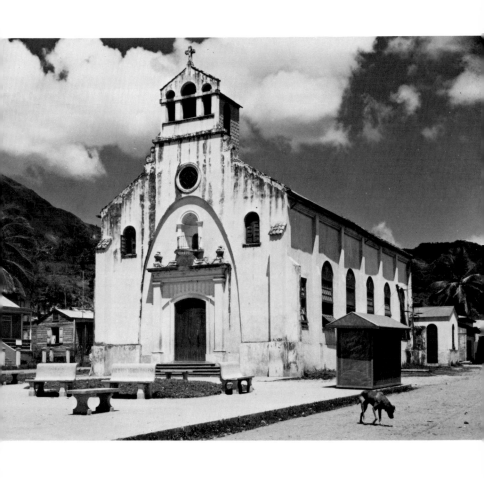

They were forest dreamers

those naked brown ones

geniuses of handcraft and fruit

lovers of sea and land.

But their islands were too small for refuge

from the *conquistadores* of Spain

from the French captains the Dutch marines

the English privateers the Yankee slavers

the Danes the Portugese the priests.

Arawak tribe! Carib! Ciboney!

All killed. Some few genes survive

from their raped women.

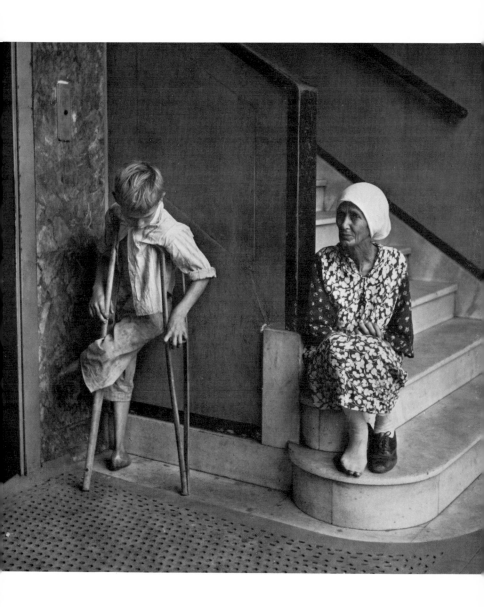

The sun sets fast in the tropics.
The house of day collapses
like consciousness into sleep.
Life seems shorter.

I thought at last of kin
the clangorous cities of home
the bright brazen girls.
My dream was no longer of islands
but of firm step upon the Continent.

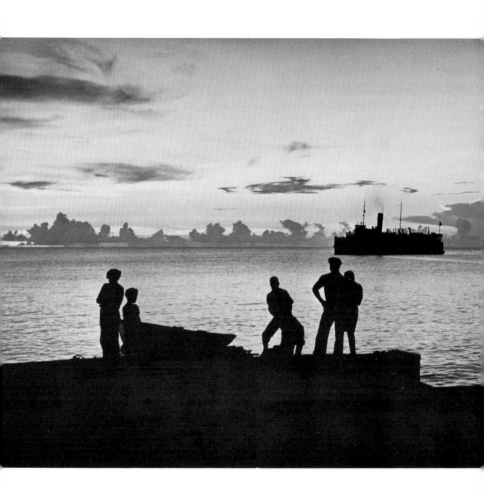

TWO
MEN AT WAR

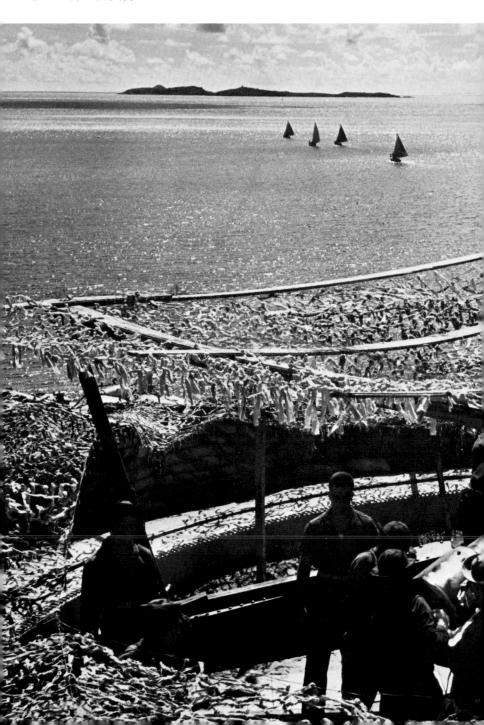

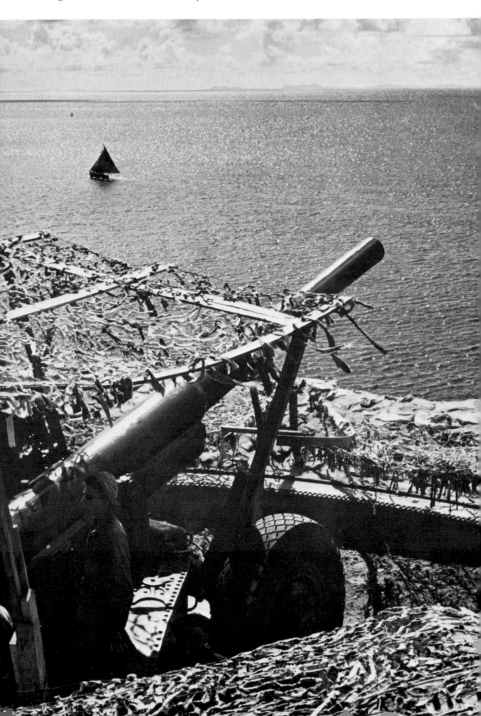

I'm glad it was Johnny

SOME OF THE BOYS

I went to school with

got their first look at an island

through a screen of fire and fear.

They found no music

in names like Guadalcanal Tarawa Kwajalein.

Their islands were green and soon red

palmsambushed beachesmined.

That's professor of English Gene Sloane center

myself on right. My camera

had a delayed shutter release

so I could get in too.

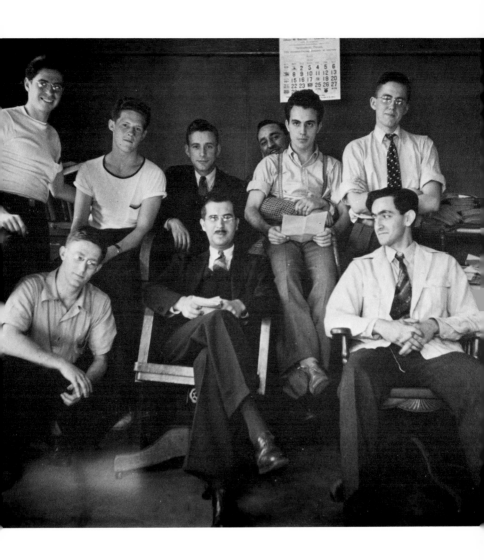

I was an objector to killing

but didn't want to go to jail.

Besides that was a better war

than the ones we've been having lately.

I went along like everybody

following orders and it wasn't bad.

They made me correspondent

for the army magazine.

When we docked at Kirachi India

I gave away my rifle.

I told myself I would be

God's spy

among the soldiers.

This is my report from that mission.

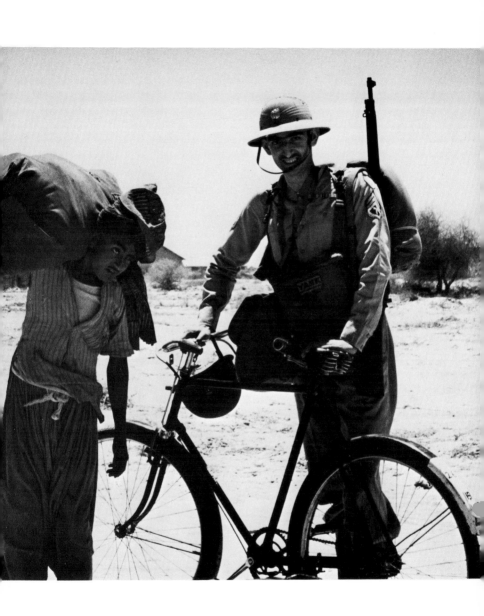

I fell in with a company of transport airmen in Assam.

From 500 feet over Burma

we parachuted K-rations atabrine ammo

to General Stilwell's malarial footsloggers.

Mostly it rained.

Food clothing paper turned moldy.

Fungus grew overnight on lenses

blistered underarm and in crotch.

Scorpions hid in our shoes.

One night we landed our C47

on a tiny jungle strip behind Japanese lines

snatched out 28 Gurkha and English wounded

vines on a wingtip.

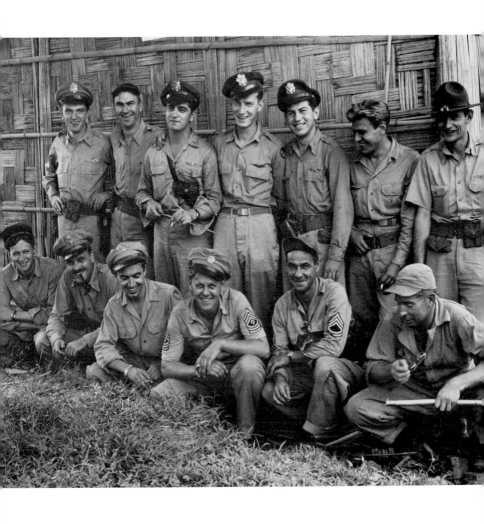

I flew up the Brahmaputra River
waterdragon flashing in the sun.

Our twoengined plane
labored elephantheavy in the sky
burdened with men and gasoline
crates of bombs and whisky.
We wheezed up to 19,000 feet trying for 21
passing oxygenbottles like hashpipes
dodging through the valley passes of Tibet.

The pilot showed us Everest.
Thunderhead clouds he said
were columns of uprushing hurricane
able to tear off our wings.
We landed in China.

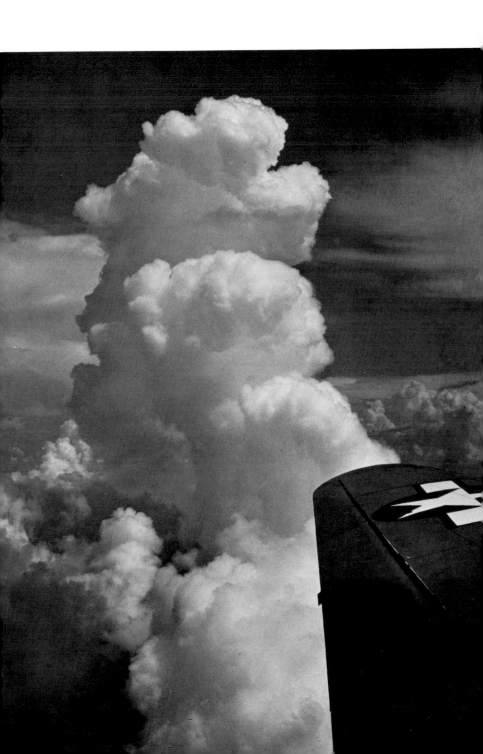

I flew on the first B29 raid against Japan.

The American superbomber

was secret till that day

a silver invented bird

of mythic range and fierceness.

It had pressurized lungs

automatic claws and beak

a radar eye.

In phalanx of sixty wings

we thundered out of Szechuan

in the amber light of afternoon

crossed China and the Yellow Sea

and came by night over the steel mills of Kyushu.

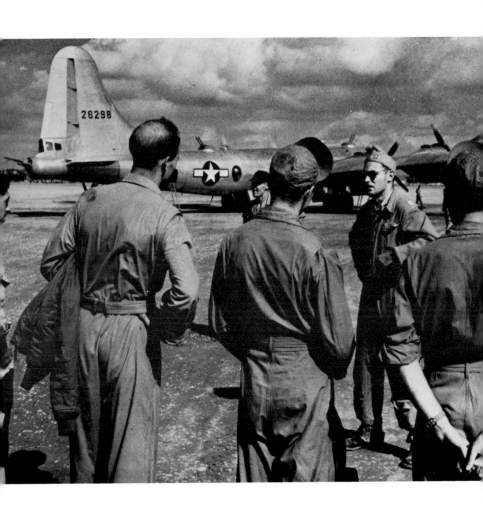

Searchlights fingered the dark to touch us. Shellbursts rocked our flight.

Most of us laid frightful eggs and got away. We had no concern for

civilian steelworkers under our bombs their homes wives babies.

Our thought was to keepformation bombaccurately saveourasses.

Kyushu was the most distant bombing target in history.

Later when Pacific islands were conquered

B29s sortied from them

on shorter missions

to Okinawa

Tokyo

Hiro

shi

m

a.

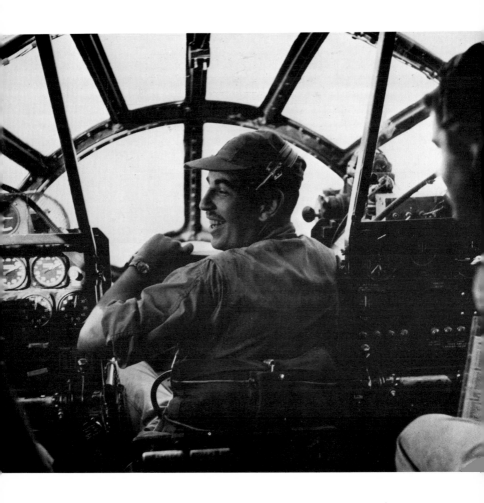

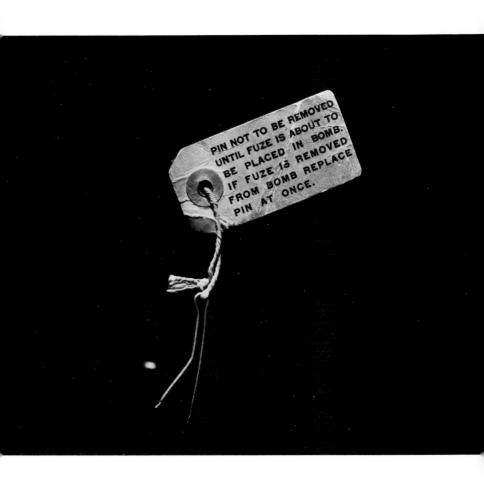

Killing is easier in air.

You never have to fuck a bayonet into a man's belly.

You're only under fire yourself a few minutes.

Air war is technical beautiful.

You watch your enemy arc down in flames

like in the movies.

You watch your bombs walk

with giant flowering steps across a city.

It's only to witness killing

not to do it.

If you get back

you're sure of hotfood cleanbed beer.

There are girls in town.

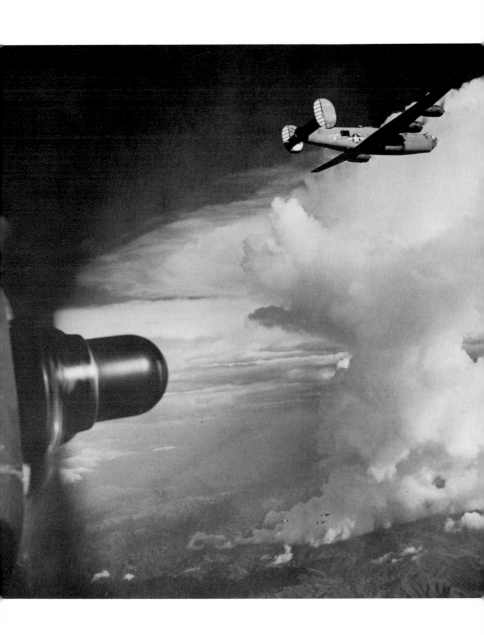

Maybe friend you were too young or old for Korea.

Maybe Vietnam found you safely in school or jail

or exile or the matrimonial sack.

Want to know how war is?

There's fighting and fear and death.

Mostly it isn't that at all.

For every man in battle

there have to be a hundred driving trucks

cooking saluting telephoning whoring teaching

armingaircraft fixingsubmarines gettingdrunk

washing glassware in the officers mess

inspecting your genitals for VD

writingandreadingandpublishing techmanuals travelorders

inventories requisitions promotions courtmartials

intelligencereports payrolls and regretstonextofkin.

Right private? Heyouthere on the double!

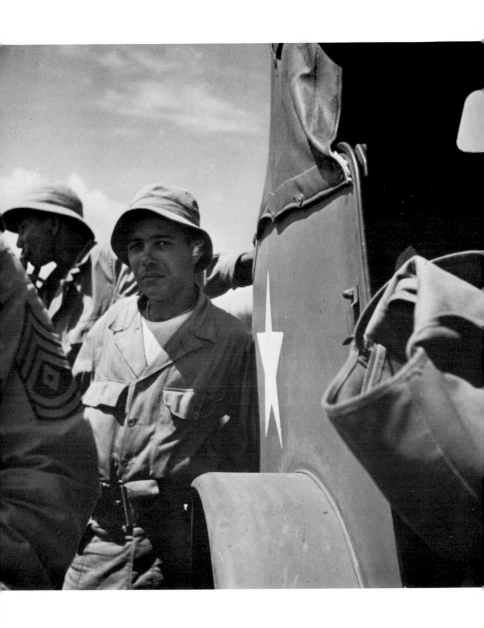

The real enemy is boredom.

Ask any veteran.

The months amputated off your life become years.

You live in a molasses river

of waste incompetence and drunken officers.

The stateside showgirl grinds her rump

at a thousand horny enlisted men

but only services the colonel.

The patriotic leering jokes

of the visiting millionaire asshole comedian

aren't funny.

It doesn't help many

to hear the fat priest from home

bless the murdering at Christmas.

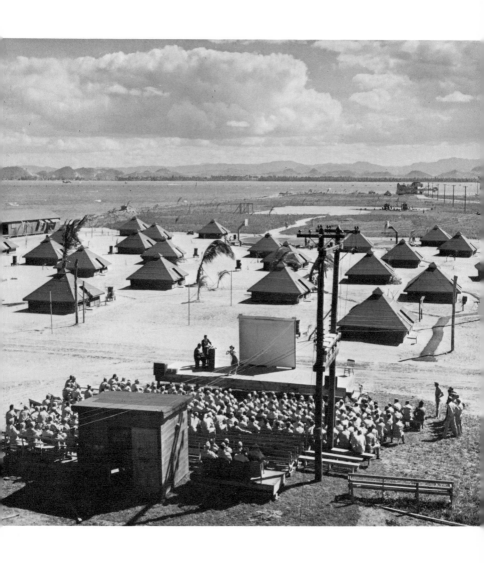

Some of us never had it so good.

Maybe home was a wornout farm

a trap of a job

an unloved wife.

Maybe home was still your father's house.

Maybe home was no work no father

toilet in the hall stopped up.

For us the uniform meant adventure

pride. War was horizon

manhood. Screw those dirty thieving gooks

can't even talk English.

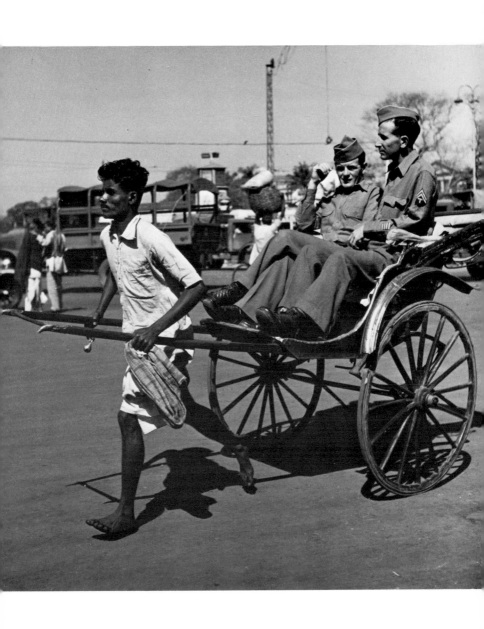

All the war cities of the world
have whorehouses.

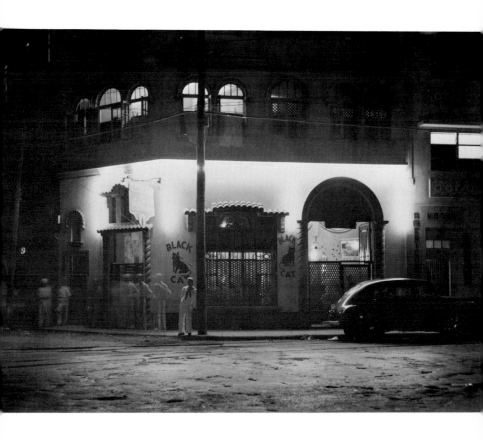

Yes sir we sure were drunk. Stanley

was drunkest of all sir. He couldn't walk

he was unconscious in a bedroom so two of us

took his arms and legs to carry him back to the ship.

Well sir we come to this tattoowallah and

Well sir yes sir it was my idea. Anyway

the needle woke Stanley up he didn't object

he enjoyed it he just wanted to know

what the tattoo was going to be so

Sir we told him it was an anchor and a rose.

But sir soon's it was done we showed him a mirror.

and sir he laughed we all laughed

hysterical so we couldn't breathe. Stanley

was laughing most pounding his foot on the floor

laughing to bust his ass. So I don't see sir

why he's bringing charges against us now.

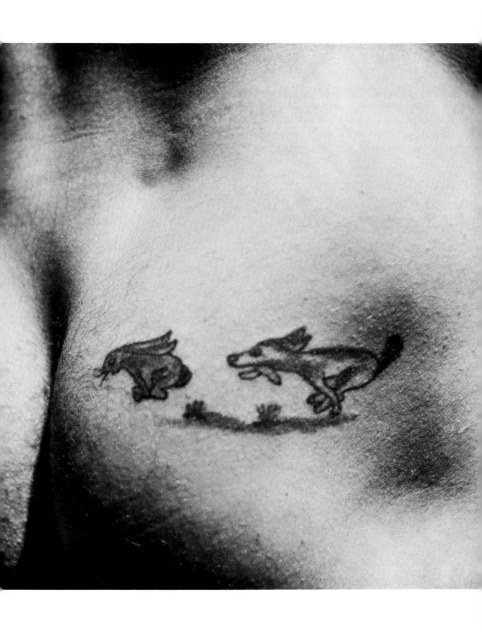

One afternoon in Calcutta

I called the first meeting of the United Nations.

In the doorway of a bar.

Have a drink buddy?

We were a Security Council in our cups

the New Zealander the Sikh the Aussie

the Chinese the two Englishmen the Maharati

the Pathan the West African the Rajput

and we four Americans. Guess who's which.

We never got to declare peace.

We couldn't figure a way

behind our officers' backs

to invite the Japanese and German enemy.

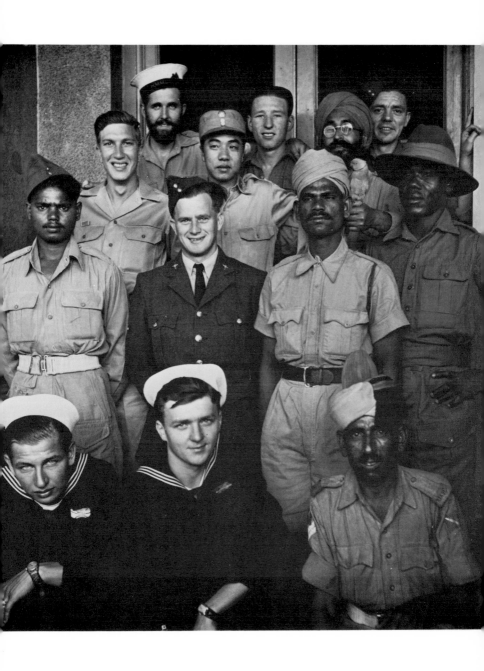

More than fifty million men women children

died in that war.

Should a man kill?

Should an invaded nation resist?

What is a nation? South Vietnam? Cuba? Israel? Taiwan? Spain?

Czechoslovakia? The Confederate States of America?

Do the means determine the end?

Am I my keeper's brother?

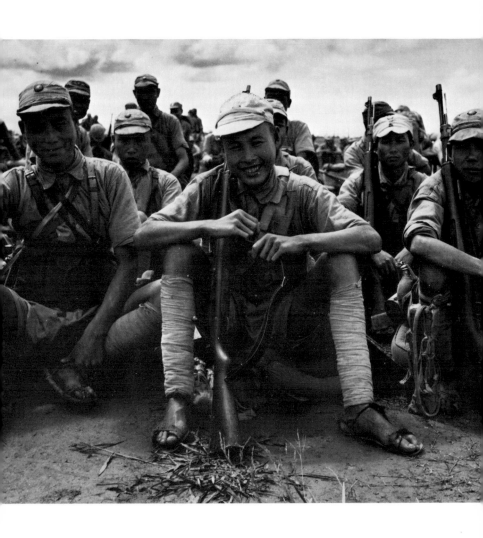

It's bitter truth

that the closest a lot of my generation ever got

to loving

was in the murderous comradeship of battle.

Sweet wife

do you think you can ever love your husband

half so much

as his tailgunner did after fifty missions?

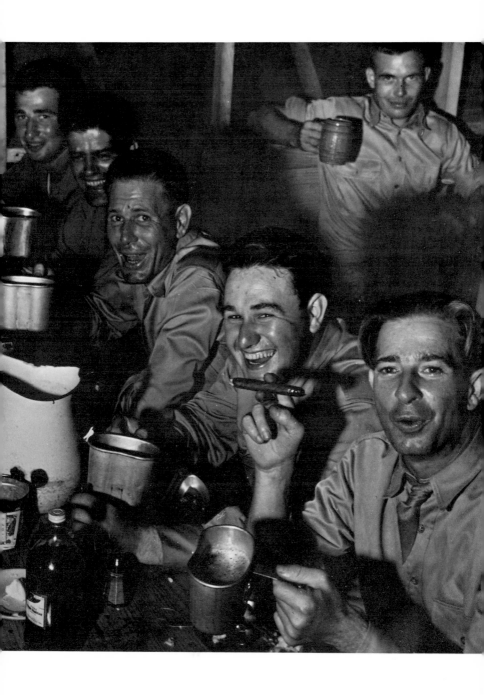

See the pretty palms shredded by artillery?

See the brave soldiers advancing inland on the island?

This photo was made on Eniwetock by Sgt John Bushemi

just before he got his throat cut by a mortar fragment.

Johnny was a beautiful photographer in my outfit.

On the hospital ship offshore his last gargled words

Make Sure the Pictures Get Back to the Office.

I think about Johnny sometimes

and I put this picture of Johnny's

in my book as a memorial.

Here lies Johnny Bushemi. He was 26.

If I die tomorrow I'll still have thirty years

of breathing laughing working balling Johnny never knew.

I'm glad it was Johnny not me.

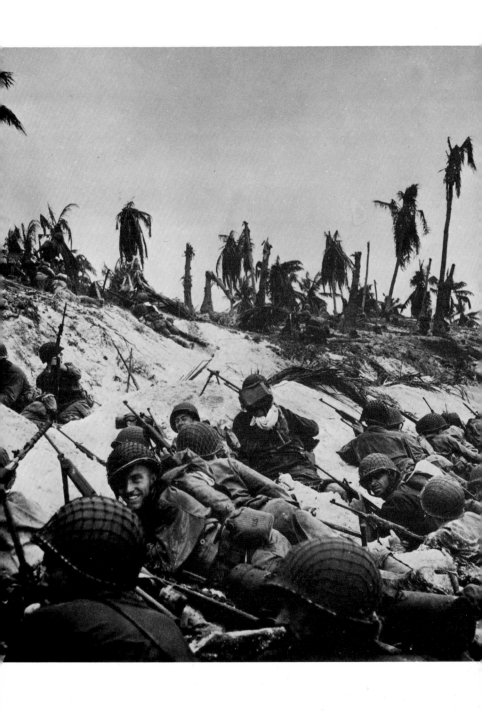

THREE
ASIA

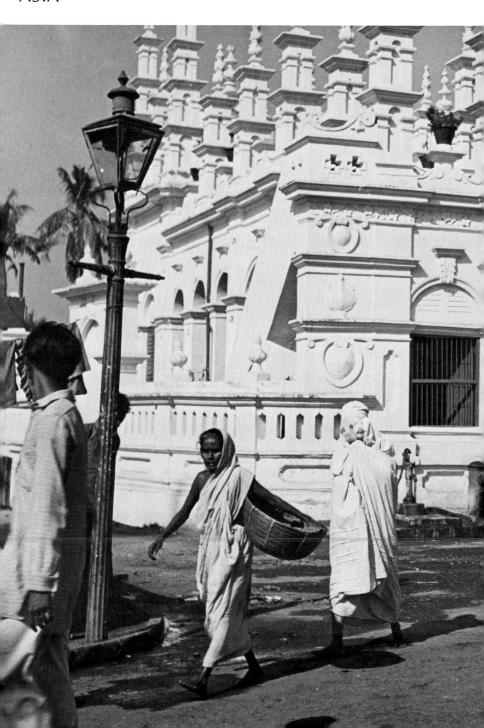

the people's river of sweat

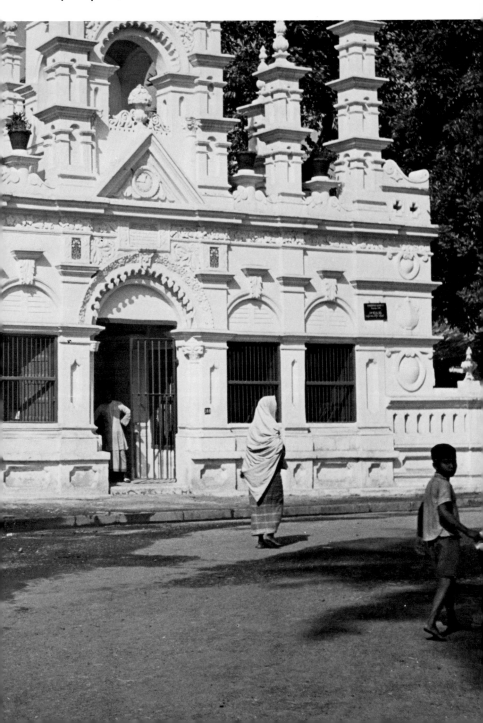

TO WHATEVER FAR LAND A MAN WANDERS

it is in search of himself.

I felt I'd been in Asia before

in that brown hooded face

in that tea house by the river

there that cripple crabbing down the street

there soft in the incense arbor of that silken lady.

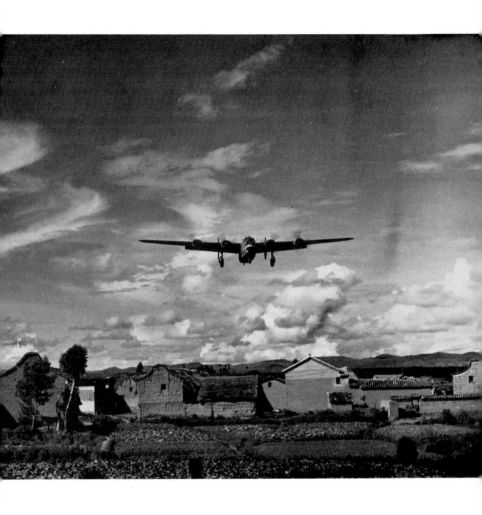

Asia seemed returning home

father's house

after a journey of centuries.

Had I never been here before?

Not in Persia? Judea? Hindusthan? Cathay?

The little mother

squatting on the dirt floor of her kitchen

regards my camera eye

across a chasm four thousand years wide.

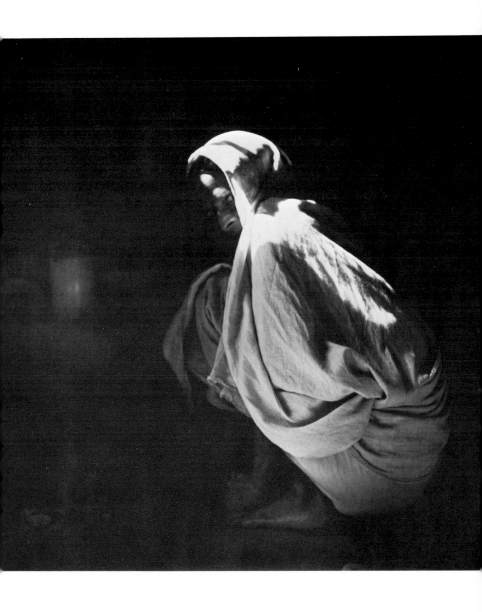

Here barbaric Christs

still curse the moneychangers

and praise Light.

Here Sound reverberates down the centuries

heartbeat of drums

kissed pipes of Krishna

and Neanderthal.

Girls from Solomon's bed

dance over grass

their scented limbs running deer

their lips honey.

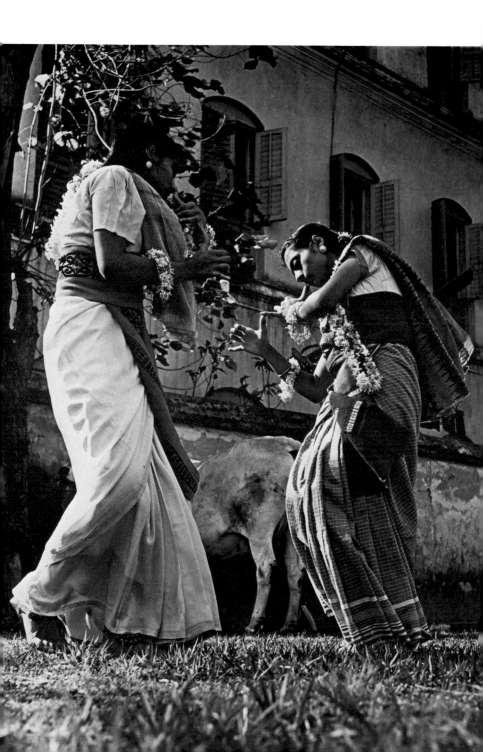

Here too are exploitation madness murder

jungle home of tiger cobra hyena crocodile

and man.

Here is land ancient as death

wise as the night smile of a young wife.

I make pilgrimage to the Taj Mahal

a pearl in sand.

Deep in the underground crypt

an old Sikh sells me

flowerpetals

to dapple on the jeweled sarcophagi

of Mumtaz Mahal and her King.

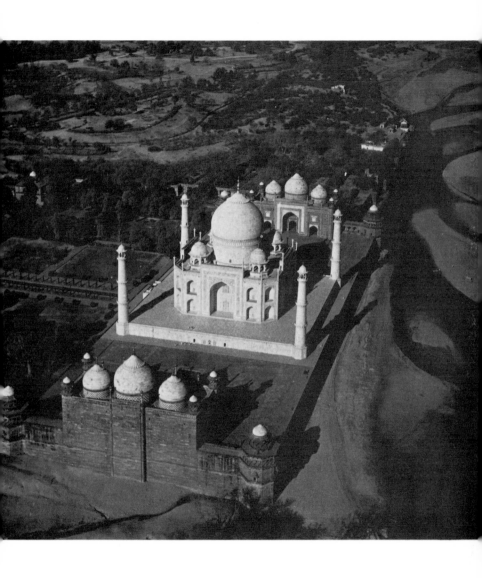

Among Asia's thousand gods

the most fanatically worshipped is

Hunger.

Cannibalism is done in His name

and child selling

and murder

and the eating of earth.

Hunger's holy word is *Baksheesh! Alms!*

His alter the burning ghat

His angels the carrionhawk and the vulture

His stigmata a marketable deformity.

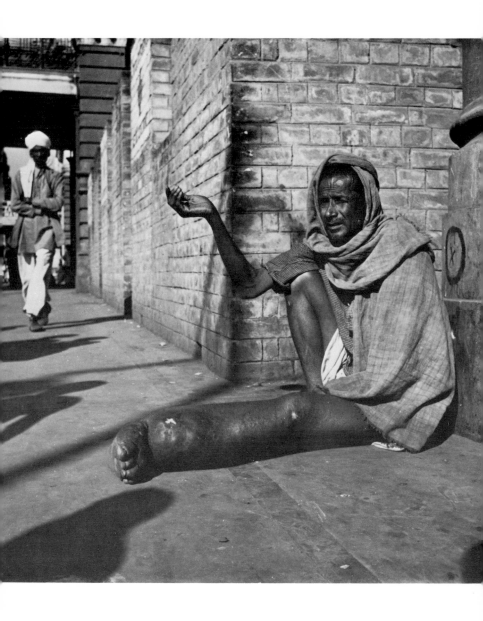

Sahib! Baksheesh!

You want jolly-jolly Sahib?

You no want me I take you my seestaire

she thirteen very clean Sahib

virgin girl from country.

You give me seegarette Sahib?

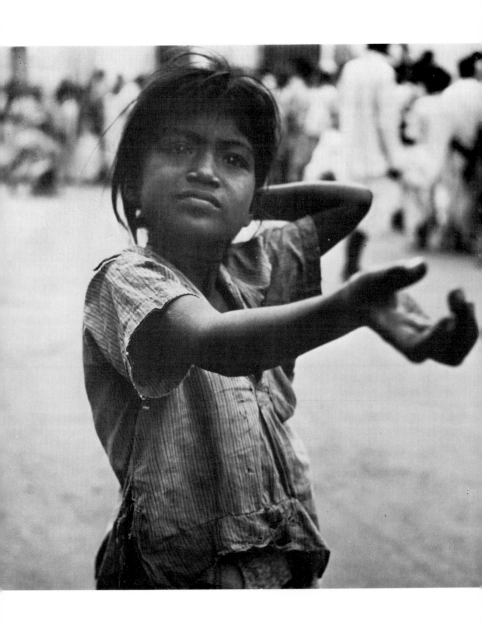

All Asia is work muscle survival.
Greater than the Ganges and the Han
is the people's river of sweat.

Peasant families calfdeep in paddy mud
from dawn till dusk
pickers of tea in the steaming fields
weavers of cloth and of straw
watercarriers hunters healers fishers tanners
miners smiths woodcutters pimps whores dacoits
collectors of taxes and of dung
ant armies of coolies crucified between cart shafts.

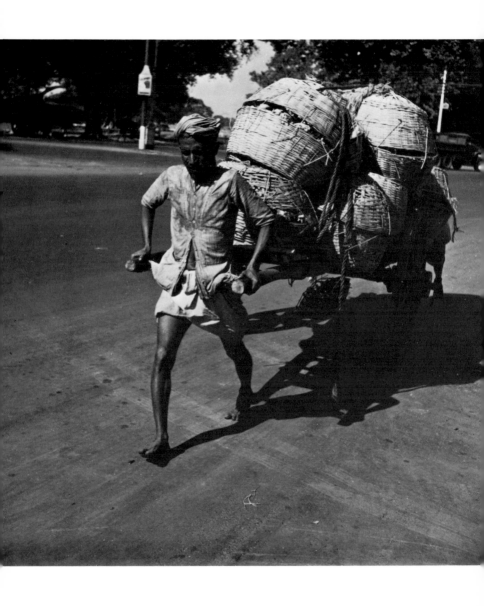

I was a wanderer in Asia

a long generation ago.

I was young then

a foreign soldier bringing war.

What I remember now

an age and a globe away

is not war

but the people the friends

working worshipping cheated dying studyingrevolution

flowering with children.

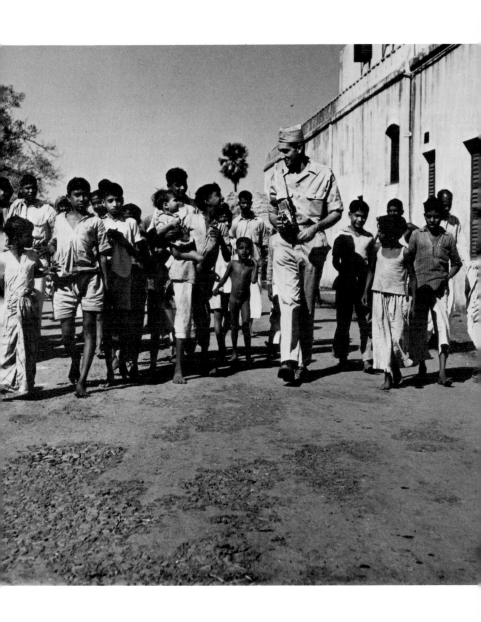

I remember the walled city of Chengtu

green rain in the bamboo groves of Sylhet

a hooded family of three lurching camelback

over the Sind desert.

I remember carp and children

in the pools of Intally

and how monsoon mornings the mist

rose golden to the sun.

I remember the smell of carbidelamps

mulberrywine and women

in gay Kweilin.

I still hear the laughter of a hundred cities

the street cries

the shouts of love and commerce and anger.

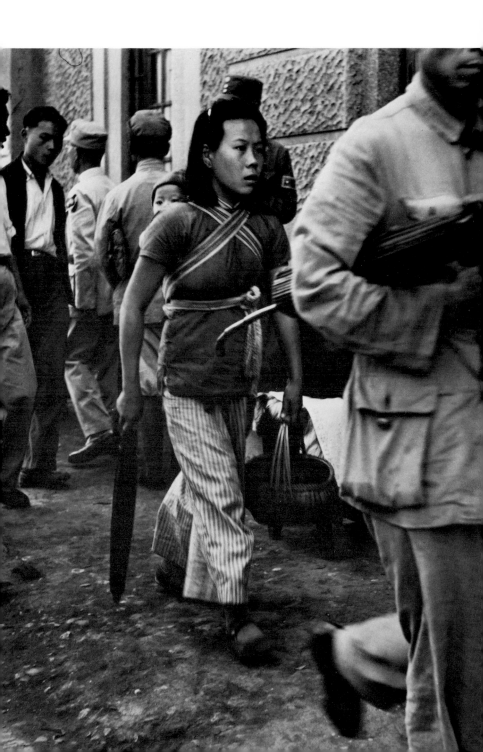

How could I forget the tender maid of Calcutta

Sunnanda the flowerfresh

and her mother who sang with Tagore

her father who marched with Gandhi?

How could I forget love

and grief

for the gentle professor of Kunming?

He served us tea in jade cups

was assassinated on campus

by political police of Chiang Kai Shek

using American weapons.

Sleep well Honored Teacher

young winds freshen in the world.

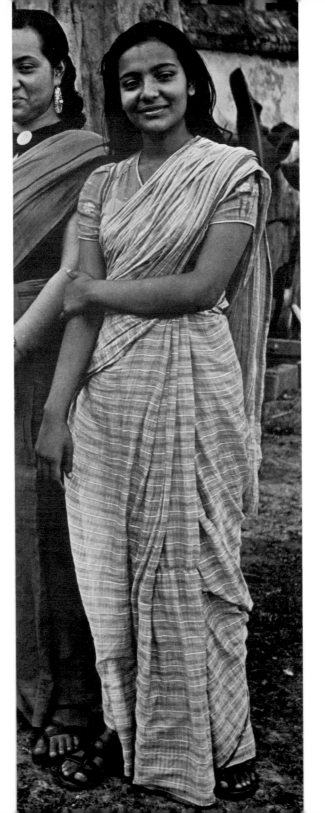

Hello! Farewell! Auf wiedersehen! Sayonara!

Bon Voyage! Hasta Luego! Nasdarovya!

Habu hao!

The villagers of Szechuan

have never seen a Long Nose so close.

They are delighted how big and foolish I am.

They think the American jeep is very beautiful.

Is it true there are also poor in America?

One immortal family

under the single roof of sky.

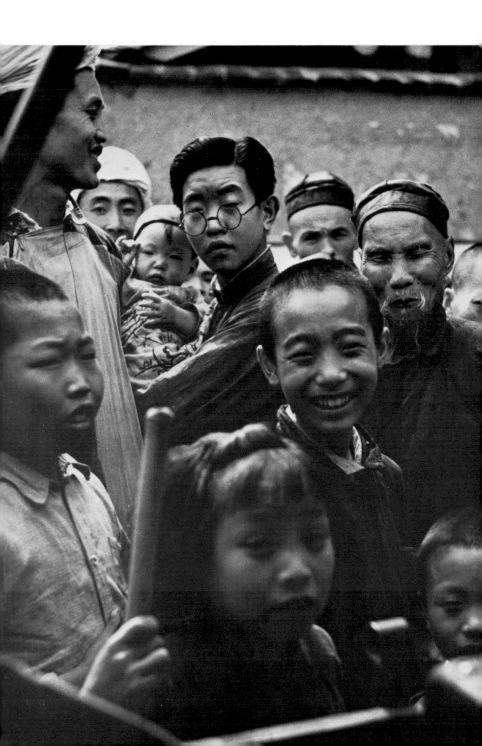

FOUR
U.S.A.

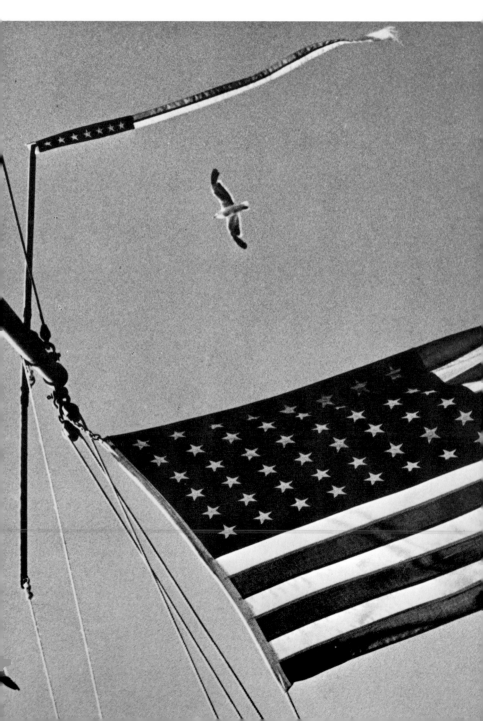

toss her cloudy hair across the continent

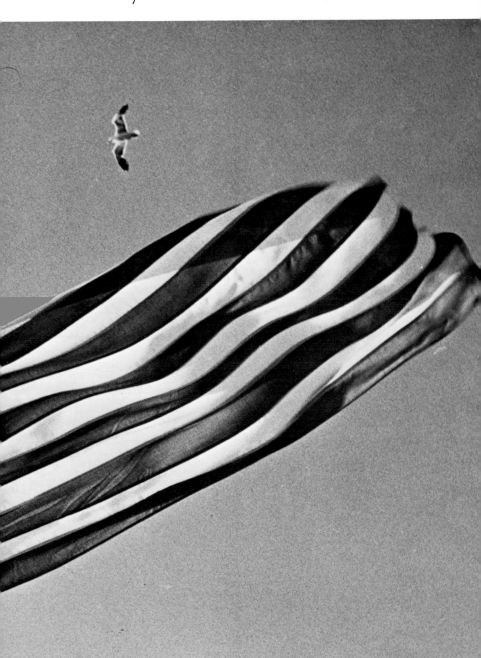

TO WHATEVER FAR PLACE A MAN WANDERS

he must at last come home.

How can you know the world

if you don't know your native land?

How can you know anything

if you don't know yourself?

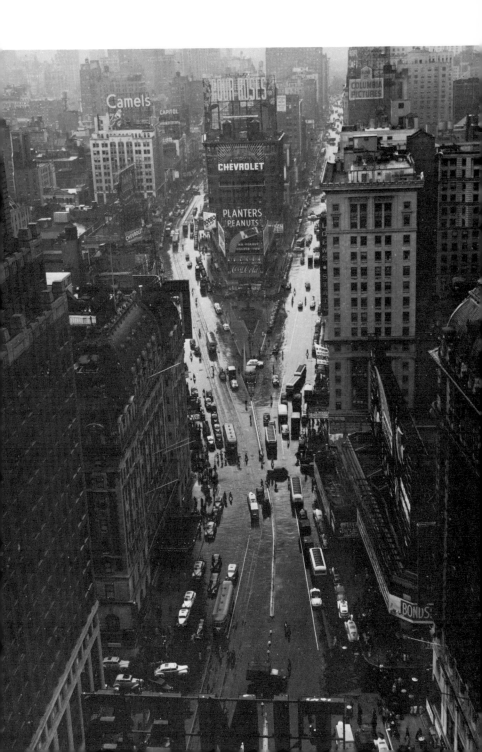

I've always wondered what makes us
Americans.

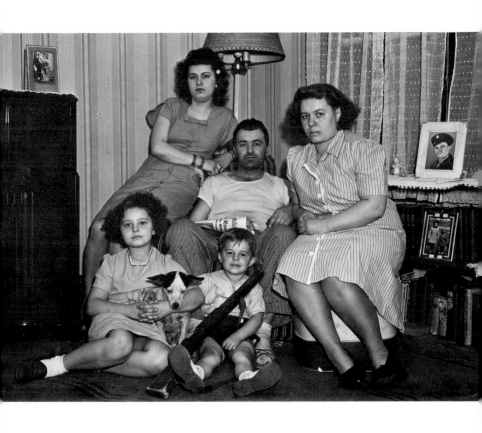

Is it the beauty of our land

and our love for it

that make an American?

Is it knowing America in its seasons

Spring on the seacliffs of Big Sur

Colorado at roundup time

the green of Mississippi in July

white roll of Pennsylvania hills in winter?

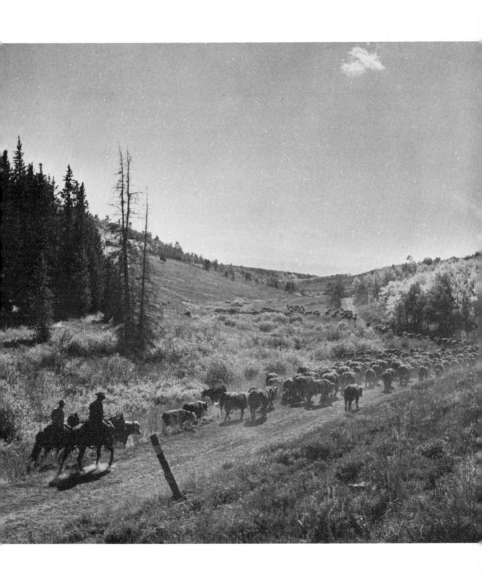

Is it having worked in America
cleared the land of stumps and Indians?

Is it having quilted a bedspread
minedcoal taughtschool organizedaunion
foughtawar builtautomobiles ginnedcotton
enforcedlaw bakedmincepie dreamedarockettothemoon?

Is it farming wheat out of the land
corn berries melons maplesyrup grapes?

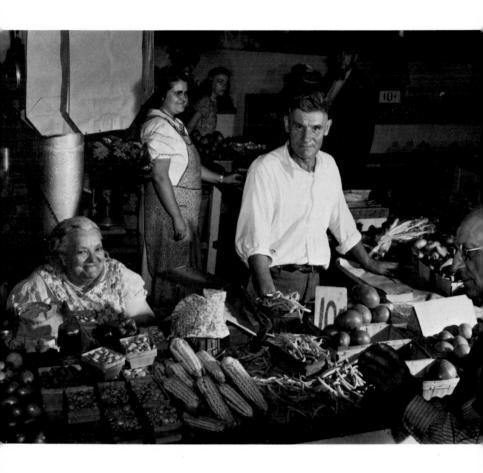

Is being an American

singing the songs of America

worksongs Indiansongs seachanties

hymns hillbilly wobbly dixie yankeedoodle

blues acidrock rockofages soul and

willyoulovemeindecemberasyoudoinmay?

Is being an American

knowing about TomPaine TomSwift TomEdison

JoeHill AbeLincoln MaeWest DWGriffith FrederickDouglas

MalcolmX WaltWhitman CalCoolige MargaretSanger

MarilynMonroe CharlieManson RichardNixon?

Is it GOP DAR KKK FBI IRS CBS ACLU CIA

ITT NAACP AFLCIO LSD IOU?

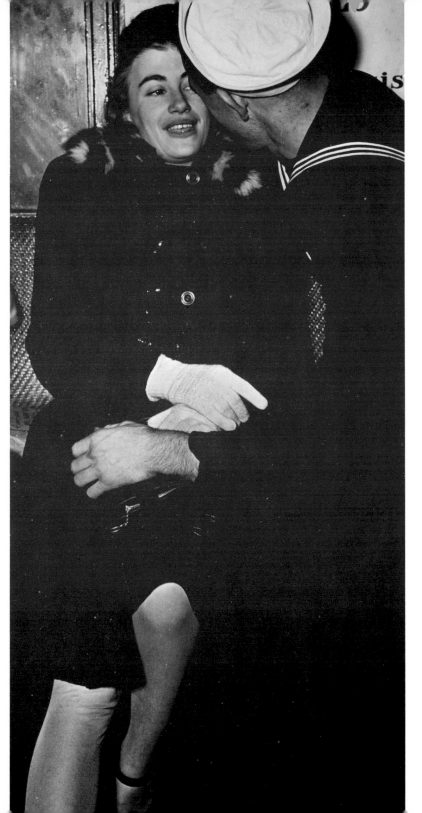

Maybe American life has a trick

of shaping anyone who lives it

giving them an American look

making them be

Americans?

The real trick

is to become a woman a man.

That's hard with all the changes happening.

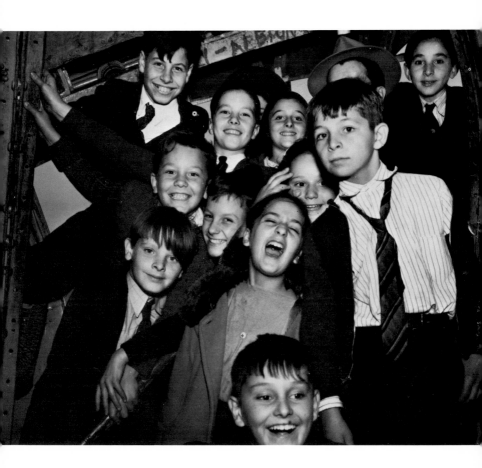

American life

when I came home from the war

was foodrationing carpools highwages

prettywidows newbabies

businessmen who'd stayed home and got fat.

Hey sailor lemebuyadrink!

You found you weren't dead hooray.

The goldplated discharge button

and a dime

got you a nickel cup of coffee.

Your friends were in London

or lost at sea.

Your girl was married.

No we don't have any openings today

for machinegunners.

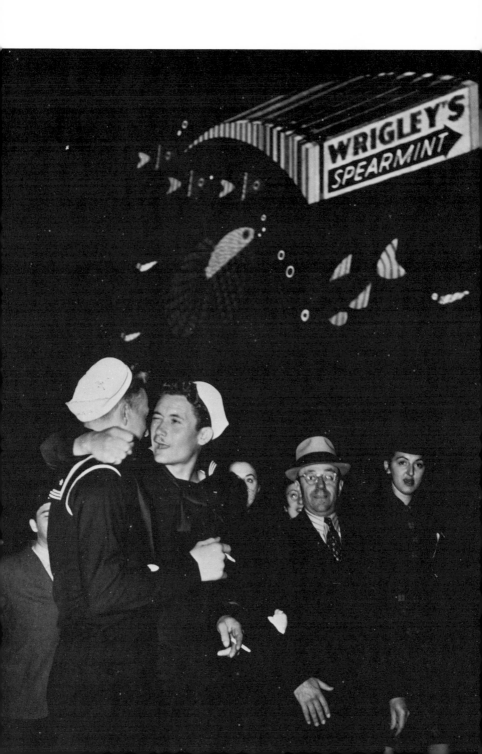

Everybody was asking questions.

Under what pile of papers did I mislay my youth?

How did I of all people miss out on the gravy?

Did we have to drop that bomb on Hiroshima?

Why don't you niggers learn professions

and clean up your neighborhoods?

Are you now or have you ever been?

When will the repairman bring back my TV?

Why must man pass so quickly from childhood

to adultery?

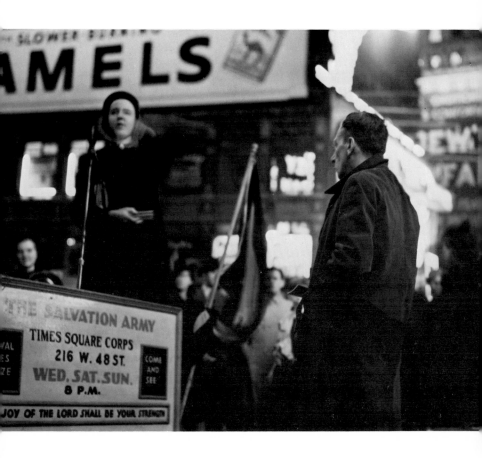

I looked for my own grief

and found it

moving fast in and out of five cities

many jobs and two marriages.

One day after the war

I came close to numb anxious crazy.

I know what that's about now

can see it in others.

It's loneliness lovelessness.

Crazy equals bodychemistry reading of zero love.

Emptysville.

Shit City.

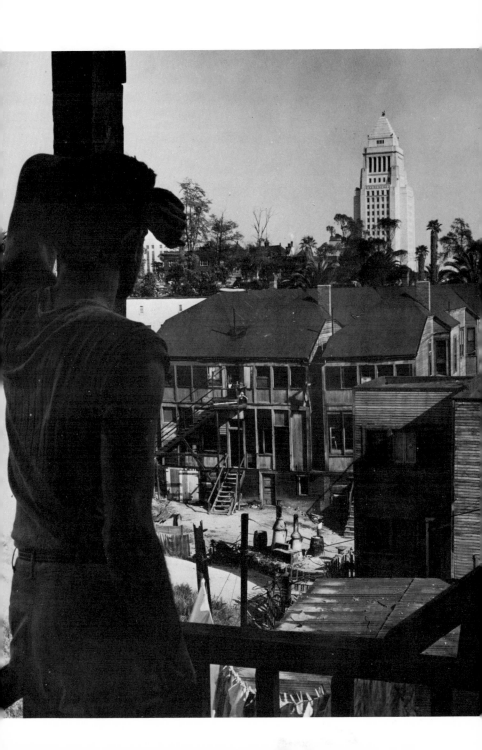

Only thing I could think to do

was drag a chair to the back porch

put a mirror on it

and shoot myself.

There I was in the mirror

hello upsidedown on the ground glass.

I recognized the man.

My movements were habitual.

I cocked the camera shutter

fired.

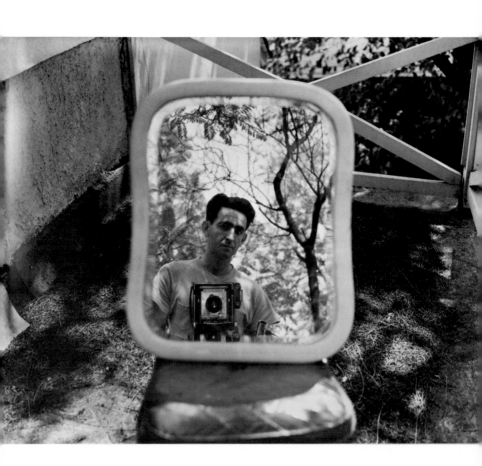

Up was only way I could go after that.

All I knew was writing and the camera.

I worked hard was lucky.

There were two Academy Awards on television.

I got a standing ovation at Venice film festival.

I drank brandy with Winston Churchill

smoked his cigar.

I walked and talked in two cities with Aldous Huxley.

I bought a Jaguar automobile with redleather upholstery

raced it from London to Rome.

Marlene Dietrich cooked me an omlette

alone in her Park Avenue apartment

at 3 AM.

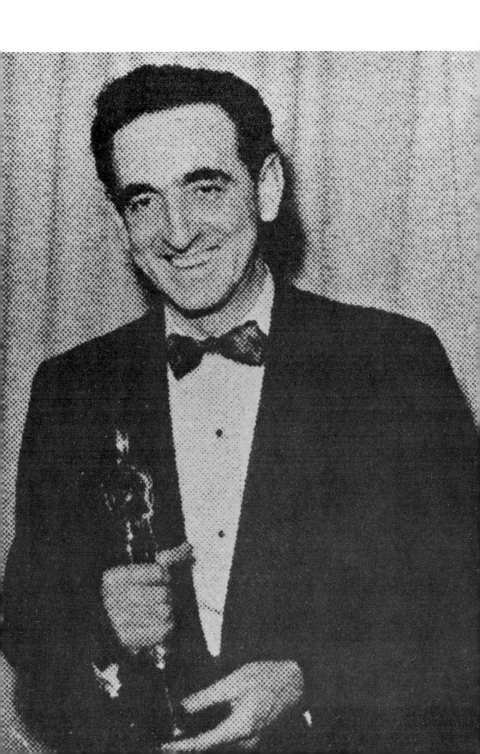

Then I dropped out of the movie business

wasn't sure why.

I'd finished a marriage and a movie

in New York City

both to bad reviews

maybe that was it.

Maybe worrying about actors critics productionmoney

I felt I was losing my art.

Maybe without a wife

I wanted to be useful to somebody.

It seemed time again to see a desert

walk under redwoods

shed possessions.

I crossed the country to California

found a job as professor.

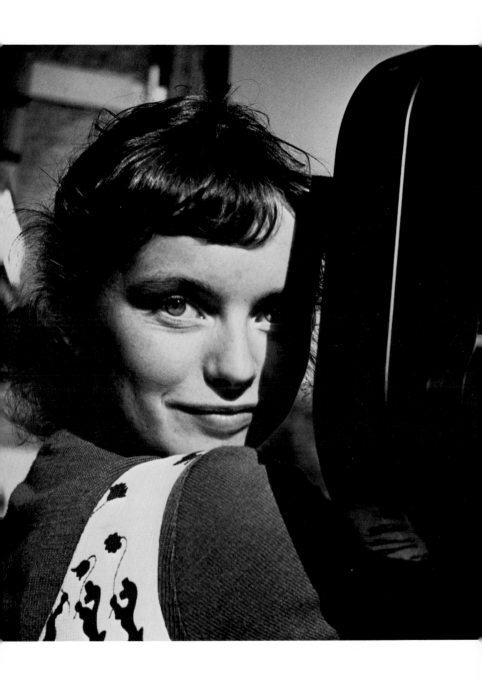

Teaching wasn't as I first feared

a copout from struggle.

The students were more engaged

than my boughtoff contemporaries.

They taught me more than I taught them.

This was the tribe

that forced the stopping of a mean war.

They invented new music poetry dress

ethics love.

I trembled before the bloom of the girls

the lean electric force of the men.

I figured some of their dew roses vinegar

might rub off on me.

Hey

could I defect from my generation?

What the young hated most

was lies was war

and got clubbed for it.

Meanwhile we gave medals for high body counts

taught our kids distrust jealousy and winning

killed thousands of ourselves in the streets

including one president.

Sometimes we're so crazy

we think the glory of humans

what we really are

is white is black brown yellow right wrong

communist republican quaker jew presbyterian.

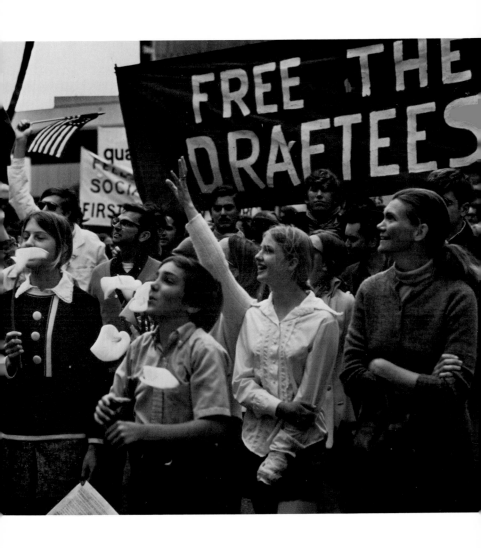

But we have all we need

now

in this lovely land

the wheat the circuitry the energysources

the youngpeople the knack.

America could laugh

and toss her cloudy hair across the continent

wash the dried brown

out of the crack of her ass

out of her rivers forests streets air soul.

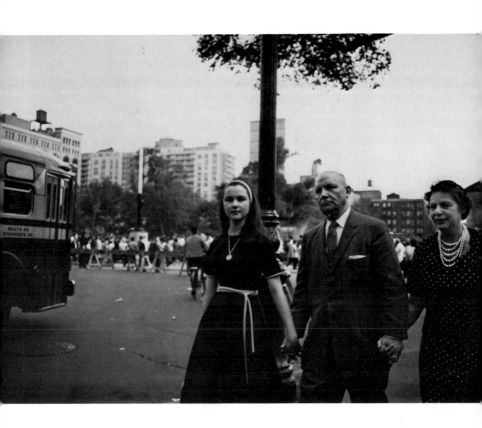

New cities could be

trees cleanwater and food

care for fish insects animals plants birds children.

People first

corporate profit seventeenth.

In Washington a Department of Joy.

Make truth love and humility

prerequisite for public office.

Let the profiteers

the oilpolluters

the advertising hucksters

the religious liars

the dealers in money and guns

register at last as subversive organizations.

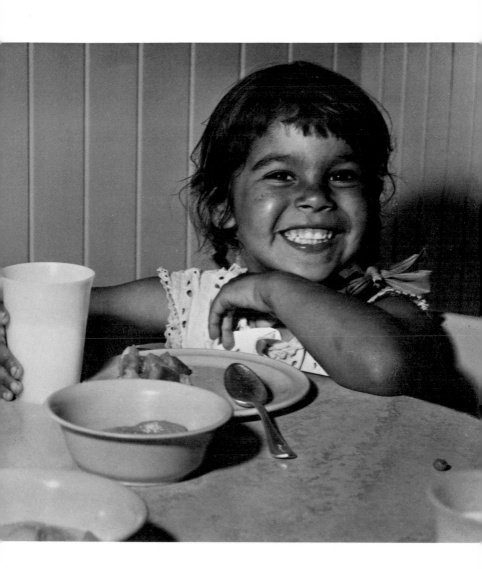

We could do it.
America could help lead humanity through.

There's a worldwide interregnum coming
already here
heavy dues to be paid
for selfishness killing and ecological sin.
But look around us now
at the trees the children the moon.
Hasn't our planet grown suddenly small?

The truth is we're suffering
birthpains!
Humanity is one spirit, mutant.
We flower as irreversibly
as seed to fruit.

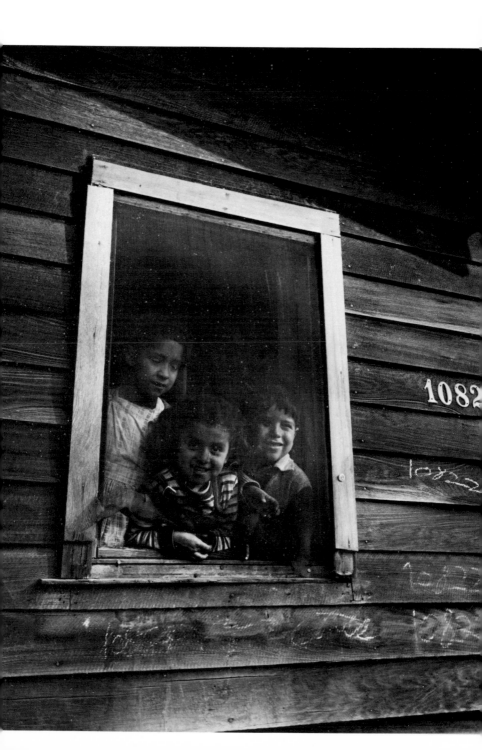

Who says we have to flay and scourge ourselves

as our parents did?

Who says a neighbor is rival

or enemy?

The time comes near

to bury nations

in the holy dust of earth

and embrace brothers sisters.

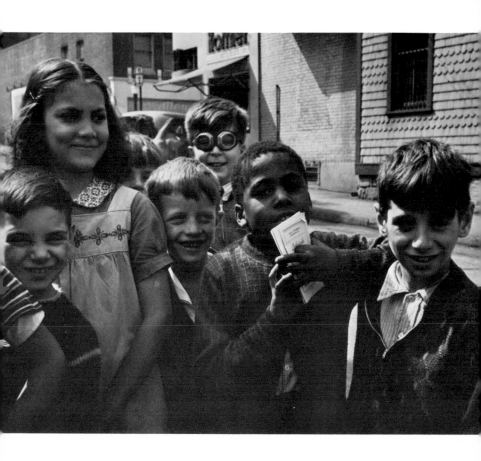

FIVE
THE CHILDREN

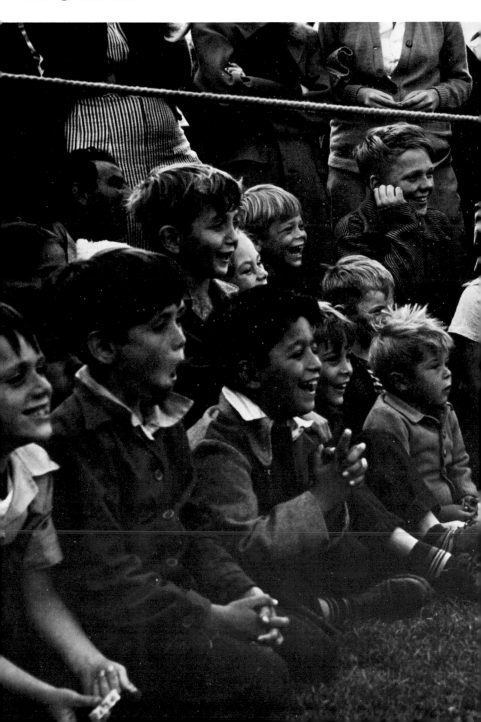

can't argue with sunrise

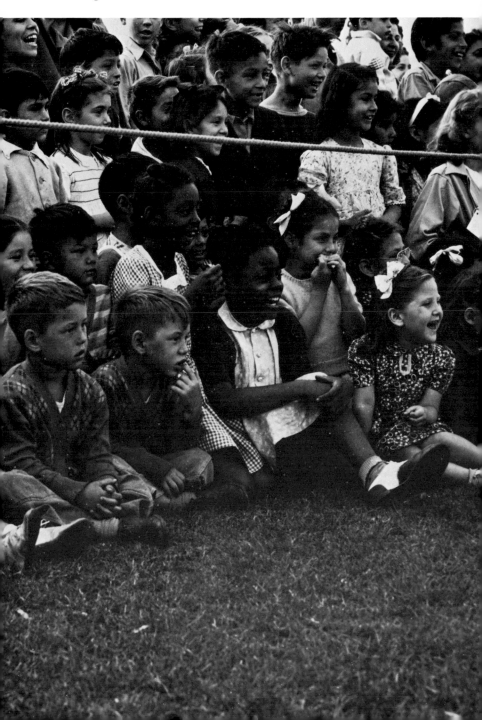

THE VERY YOUNG

know nothing of nations
or wars or islands.

Warm arm holding
is earth.
Mother's breast
is great bowl of sky.

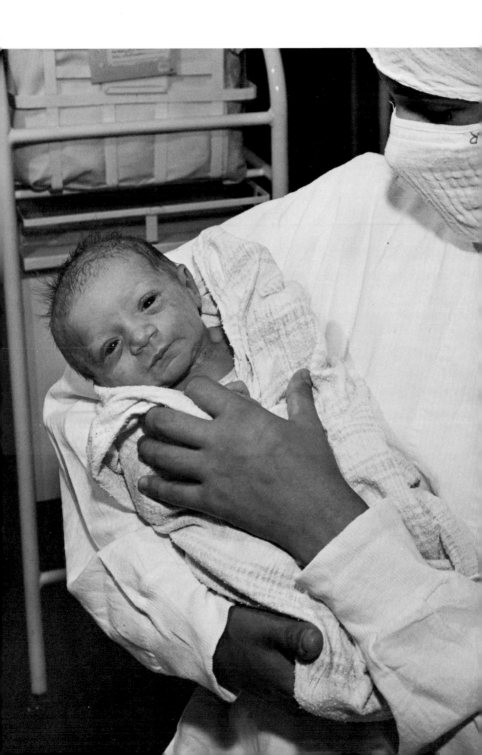

One's own childhood

is the strangest island

so magically far

that once you've left it

you can never return.

Where was I yesterday?

Where was I before I came to this world?

I can't remember how it was

to be a baby.

Did I really come out between mother's thighs?

Did she cry?

Was her pain great?

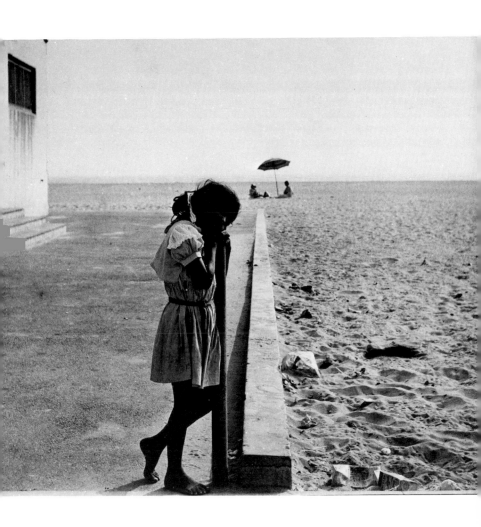

In all my travels

I looked with wonder at the children.

They seemed old friends

come to greet me

from the distant island of my own beginnings.

There are secrets between us

remembered sharings.

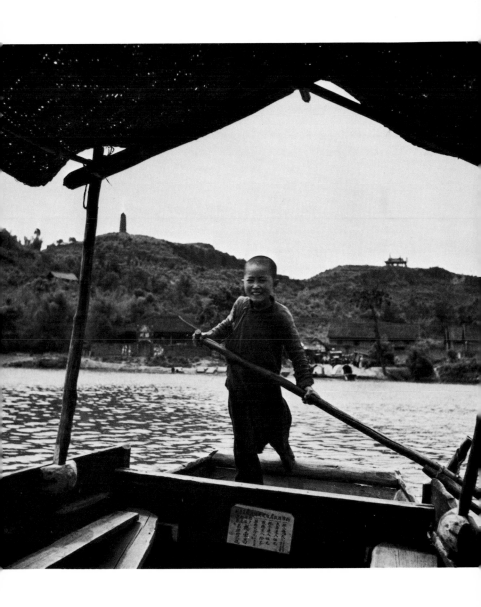

They are sweet of breath and spirit
sacraments on the earth.

As a teacher
I've learned I can teach them nothing
only open a few doors
steady their heads
show them thirty isn't the boneyard.

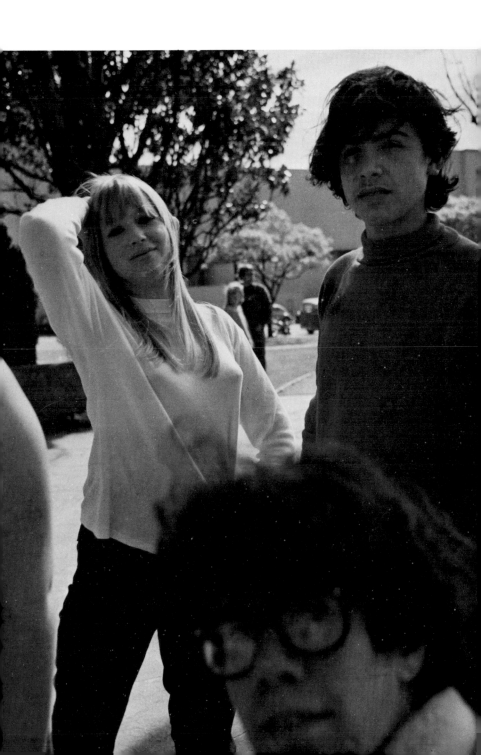

Oh some of them are a profane crew

heroinaddicts alcoholics hookers groupies

acidpeople godfreaks

warlocks bombers angelsfromhell

and heaven. *Come on baby*

only reason you won't is cause I'm black

right? Or maybe that's why you will?

Begging from tourists in the Haight

on Telegraph on McDougal on the Strip in Boulder.

Hepatitis gonorrhea mononucleosis burglary

syphillis socialism murder freelove *(oh sweetie*

you don't know how free love is

and gentle).

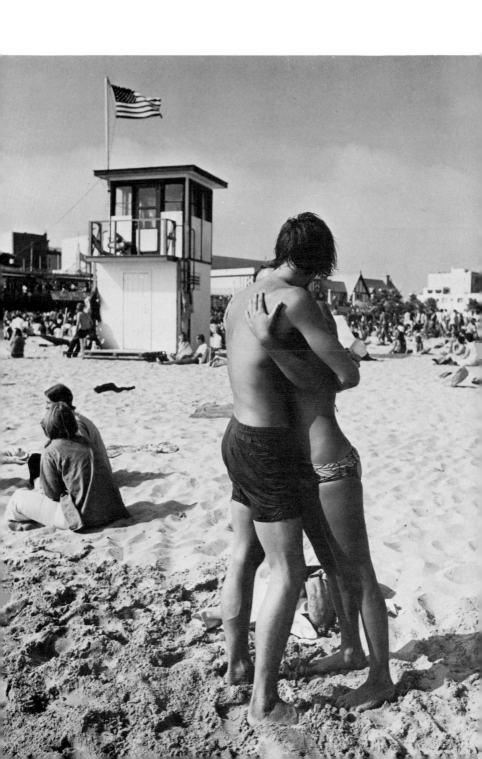

They're troublemakers nasties

tickling in there under mom's bloomers

flashing smiles and nipples at old dad

turning them on

till they know they've missed it all these years.

Busted for grass in the TAC squad sweep

of Venice beach.

Dropping acid in a church of redwoods at Santa Cruz.

Foodstamps and fatherless children.

Greasydishes in the cockroach kitchen.

Beards sandals grannydresses and crablice

hitchhiking to Calvary.

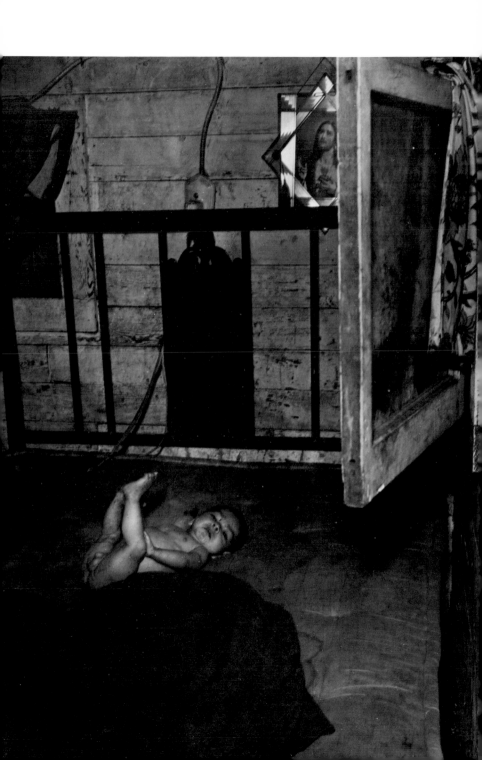

But something's happening on desolation row.

Ain't gwine study war no more.

She's touched your perfect body with her mind.

Light my fire and we shall overcome.

Om mani padme hum.

Relax and float downstream it is not dying.

You don't know what it is

do you Mr. Jones?

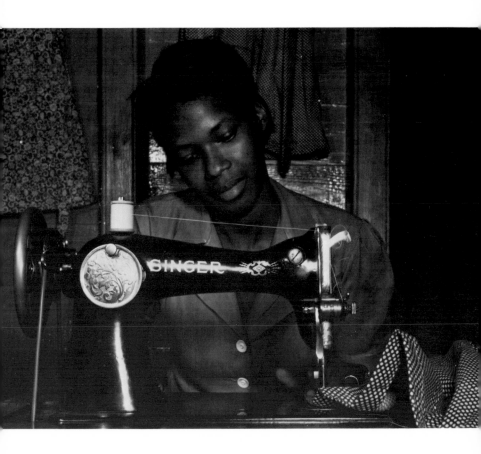

But you know baby

you and a few scientists prophets poets crazies

and old ones.

The richdiplomats the paranoidpresidents

the bishops and commissars with hot flashes

the ignoramous jackoff generals

your friendly local unionleaders and bookburners

they're lost

holding what they've got

scared mean dangerous

starting late to understand a little.

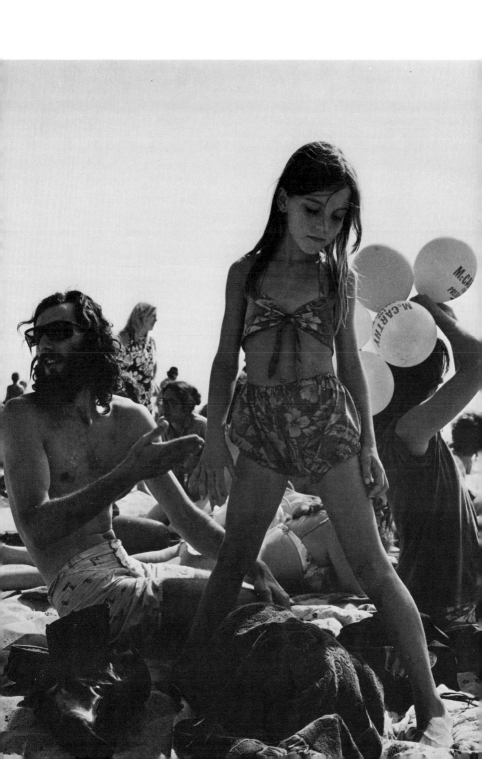

No don't ask your parents what time it is
not Mommy and Daddy.

They don't even know enough
to turn off the smog
give up guns
and look in the mirror.

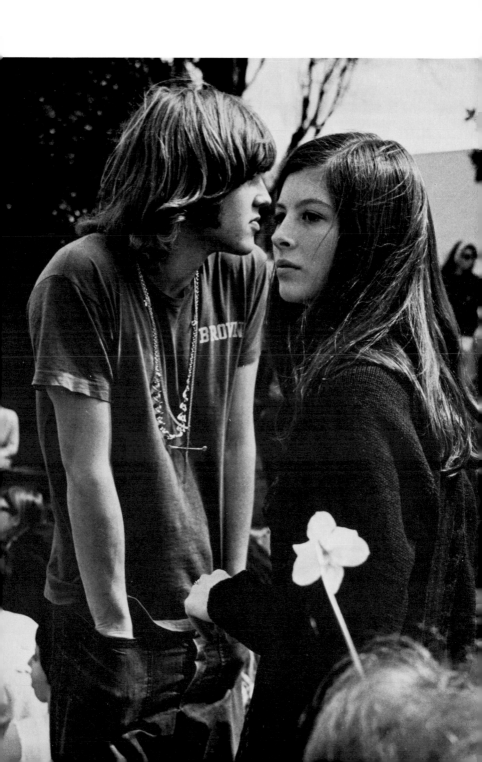

Changes coming.

Can't argue with Spring after a long Winter.

Can't argue with sunrise.

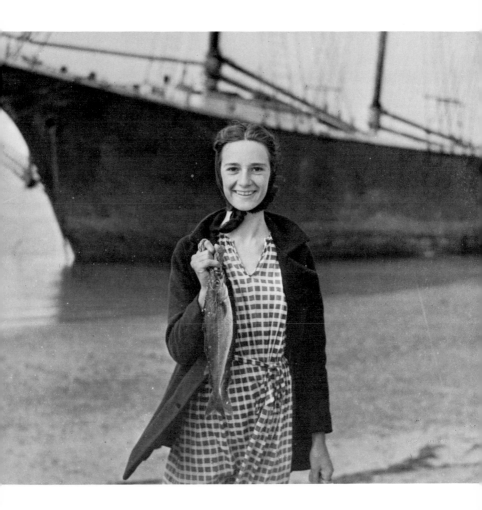

SIX
DREAM OF LOVE

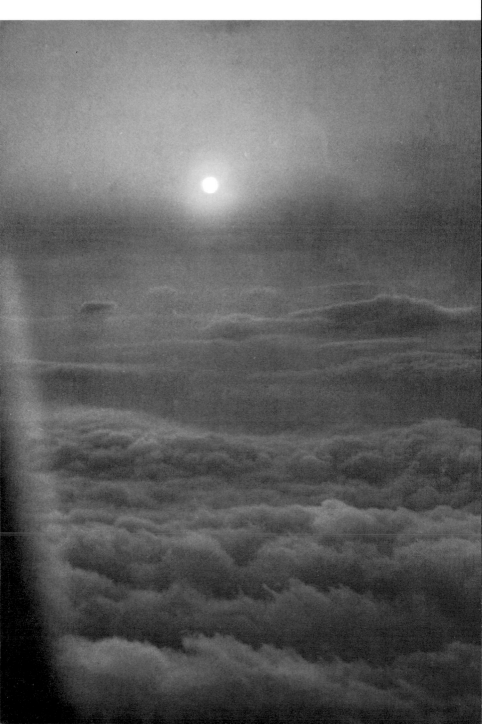

how each eye burns out through air

I DREAM OF ISLANDS

of time

of earth and space

of men and women waking

of love

of the pulsing eternal river of red blood

we all share.

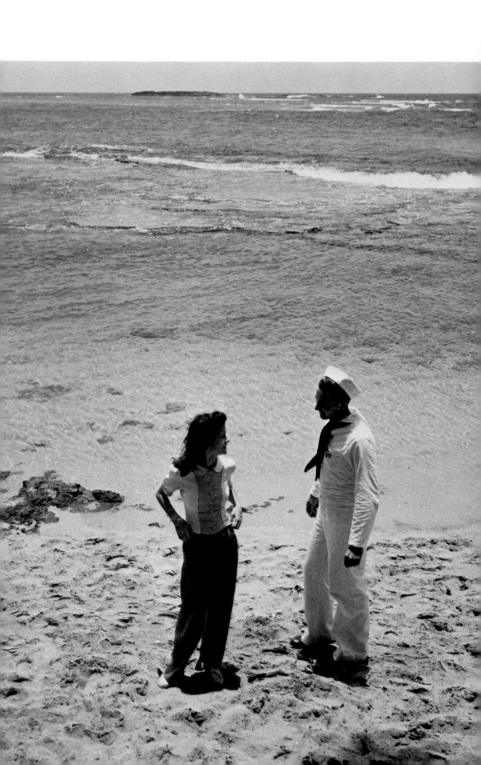

I dream of pubis

male and female

furry island on the body's ocean

birthplace

rebirthplace

mound of resurrection.

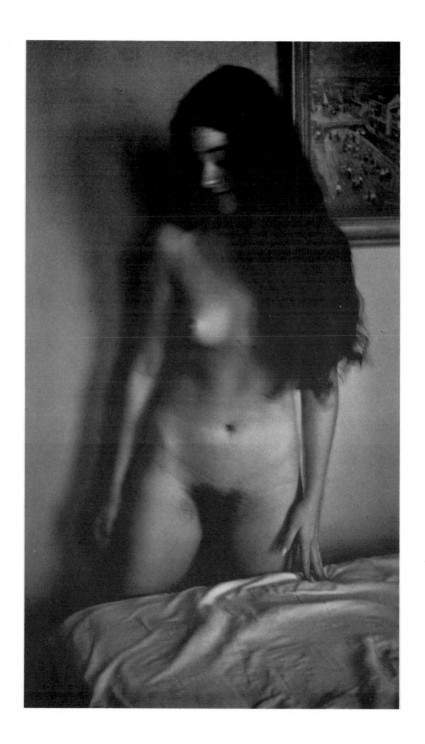

I vision the eyes of all the world's people

twin eyelights

skein of netted stars

flashing eyelands

around the ocean orb

of earth.

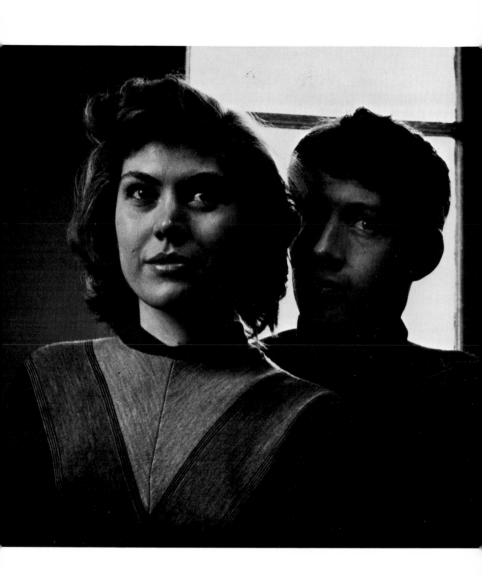

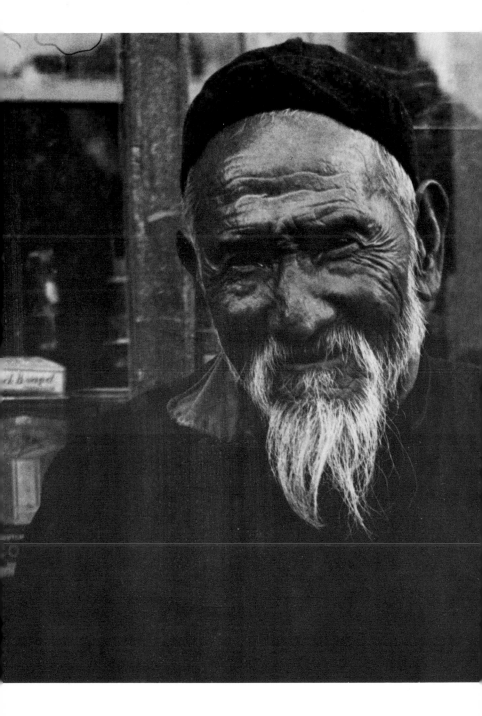

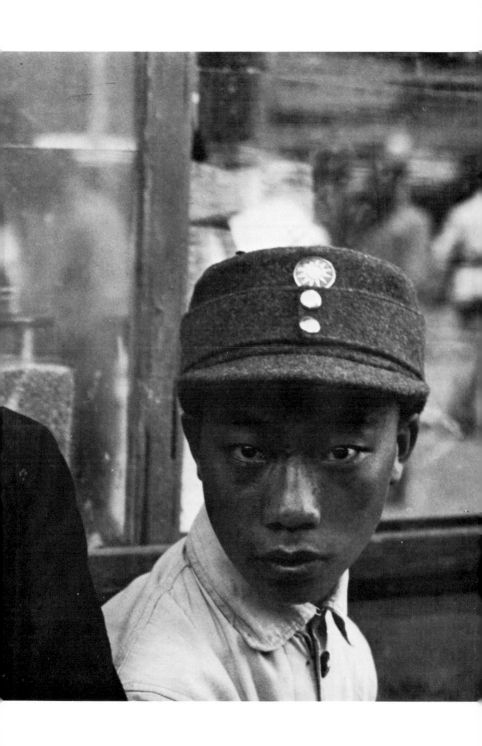

Do you also dream of eyes?

Do you too in lonliness and sleep

dream of demon lovers

heroic friends?

Do you dream

how each eye burns out through air

to meet and greet

the other's eye

in luminous recognition?

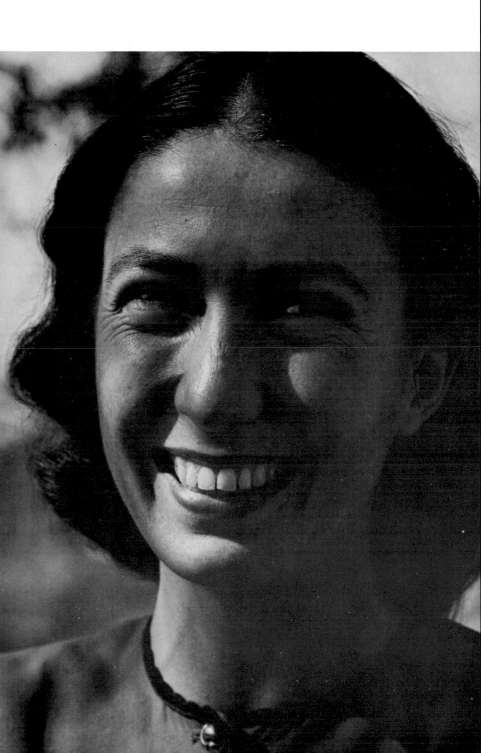

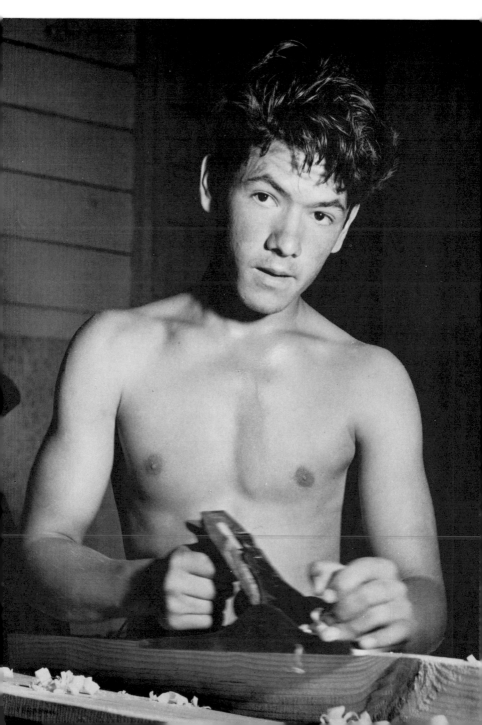

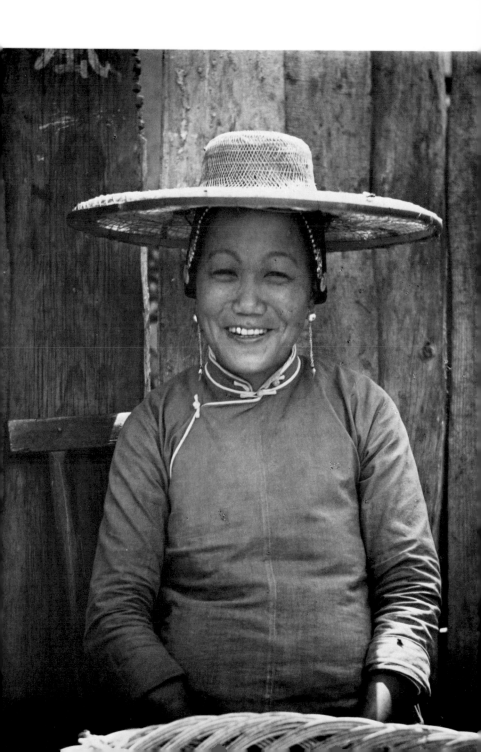

From such visions

the stars of brain's wet cosmos fire

sparking image to memory

light to sense

air to blood

flesh to spirit

island to universe.

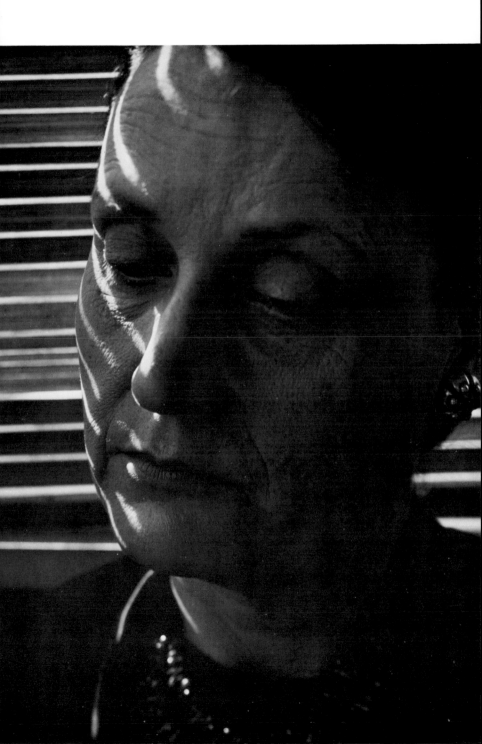

When on that beam of light

we two touch

in comradeship or love

our merged spirit

becomes all eye all light.

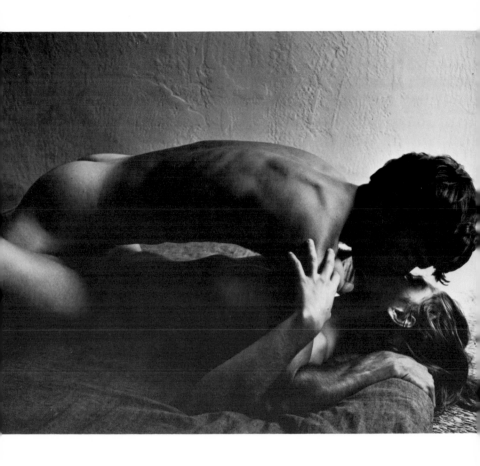

Can we dream then of a forest

feeling the fall of one leaf?

Can we dream

that a single intake of our breath

involves all the world's air?

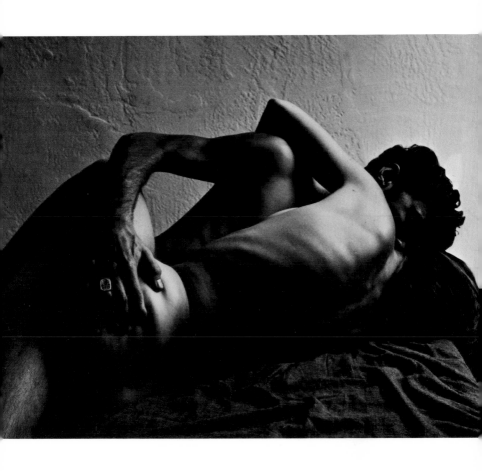

Fast then the island brain

empties of our imaged selves

and of the world and memory.

And eyes dim out

and light becomes interior.

Starshine! Sunburst!

We die are born

and I am you in flesh and light

and you are heart and sight to me.

Rainbows flesh across our bones.

We are all divinity.

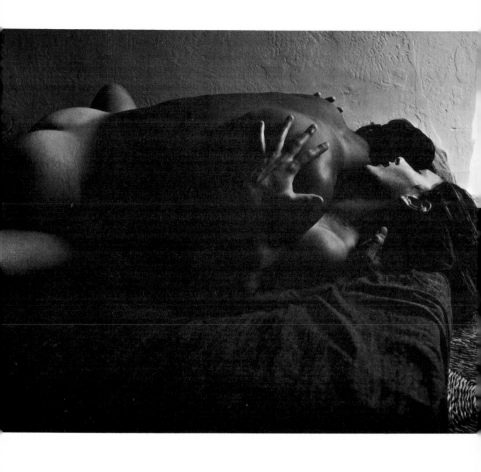

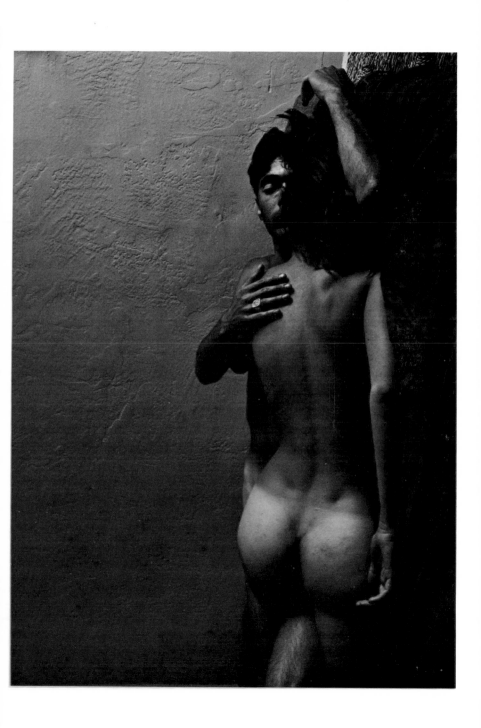

When I was a boy

in a Pennsylvania farm town

I dreamed of far green islands.

I wanted wheels sail wings

the world.

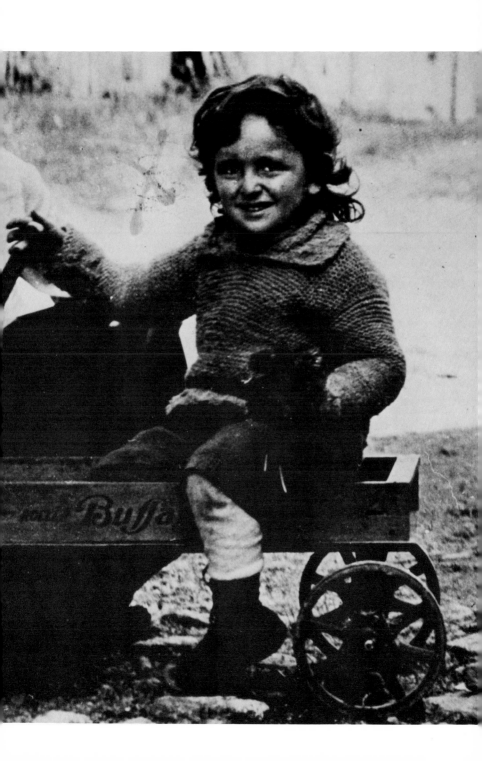

I'm learning now the true island of dreams

is no distant shore

but the present journey

the work

my being

and yours

ours

this moment

love now if we can make it.

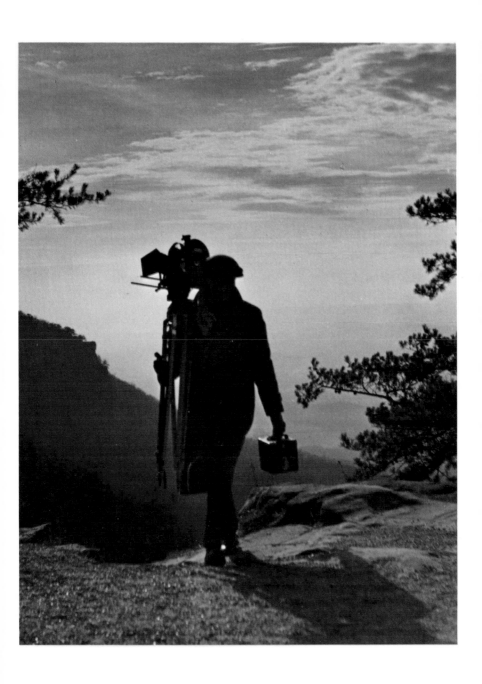

Are you also a lonely traveler?

Are you a fool too?

Aren't you a member of us all?

Do you also look for a flying horse?

A flower that doesn't die?

A kiss from God?

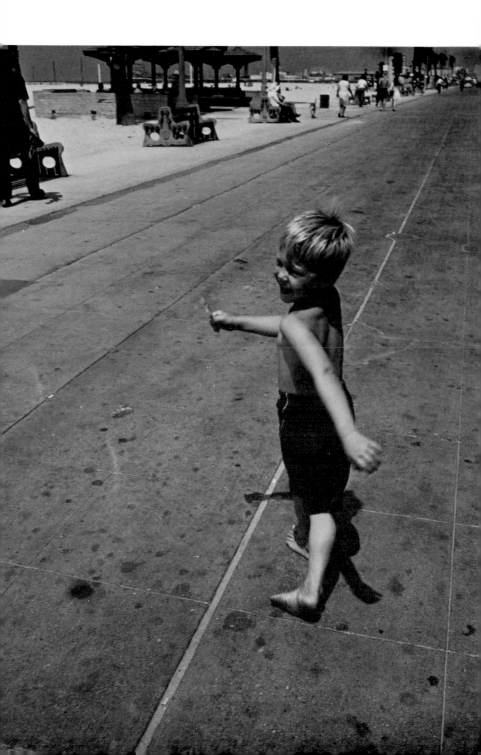

* * *

An Afterword On Movies
Light And Other Mysteries
followed by Captions to the Photographs

WHEN I WAS TEN a friend let me look into the groundglass of his twinlens reflex, and I was hooked. Photographer. Photo grapher. Light artist.

That image in the camera finder had a sudden vital excitement the actual scene (some trees) lacked. The image was more vivid than the "reality." *Wow!* was my thought. *I wanna do this thing.*

What was so special about that image in the camera's finder? Why is the photographic image — especially its galloping multiplier the movie — so very sexy? Answers keep peeling off that question, like skins from an onion.

One early answer is that the camera finder frames a part of reality, separates it from normal 360 degree chaos. The detail becomes significant. We pay attention. And close observation of anything is a meditation, it raises us, makes us feel good.

Another and deeper answer is that photography dusts us with immortality. The camera stops time. Freezes it into formed moments precise as snowflakes. Magic time machine. Microtome. *Zap!* Abraham Lincoln broods. *Zap!* The Wright brothers fly. *Zap(ruder)!* President Kennedy's head explodes. *Zap!* Man walks on moon. *Zap!* There you are, two years old again.

Cartier-Bresson has said his camera search is always for "the decisive moment." That remarkable point in time where movement and meaning converge. An airship blows up. A smile peaks. A child touches a deer's nose. Laura Huxley, on the other hand, has written of "the timeless moment," and photographers like Edward Weston have photographed it. A female nude on sand that is all women. A face, or a tree, that echoes forever.

What makes a *good* photograph? I don't know. There are many styles. Maybe camerawork is an art. One useful test is probably that an excellent photograph *sees* more than the ordinary eye. It opens things up for us, reveals, delights, evokes, disturbs, is, like poetry, a probe to expose truth.

Of course the trouble with photographs is they are singular. They don't move. They have no voice, no music. That's the power of motion pictures. That's how TV killed off *Life* magazine. In my own case, I got bored with the single image. I got seduced by the cinema. You could tell a story in motion pictures. You could *write* a movie. And I was a writer too, loving words. Besides, compared to the special loneliness of the still photographer, making movies is gloriously social. Film-makers get admired, befriended, loved, listened to. There's more money in movies. More power. Film is just maybe (next to music?) the most creatively effective craft/art there is. It combines all the old arts, and some of the sciences. It hits eye and ear and heart. It moves huge audiences. Like music, film is *now*, can be experienced only as process.

For many years, after 1950, I mostly put aside my Rolleiflex and worked in movies, first as cameraman and screenwriter, then as writer-director-producer, then as professor of motion pictures, making an occasional film, a few still photos. Five independent features. Scores of short films and TV things. I made mostly documentaries: *The Naked Eye, The True Story of the Civil War, Black Fox, Image of Love, Winston Churchill—the Valiant Years* (a TV series), *Walt Whitman.*

How can *you* get to make movies? Work. Watch films obsessively. Shoot footage and edit it. Play with sound. Put your attention and time on it. Need to do it more than anything else. Inherit production money, or marry it, or earn it. Go in the back door as bookkeeper, production manager, script girl, actor, film student, wife, lover, son. Go in the front door as writer, film editor, cinematographer, star, stage or TV director, agent, attorney, investor.

Now I find myself working some in still photography again. Close faces. People in the streets. Kids again. Moments of surprise and magic. Prints in my own darkroom coming mysteriously to life out of white paper. There seems to me now in still photography a certain purity, a directness, that I've missed. And in writing poetry, compared to writing screenplay, there is more leanness, more truth, less manipulation of audience, more freedom from the marketplace. Movies are always a frantic enterprise. The technical, financial and personal logistics are ferocious. You spend 95% of your time on contracts, money, casting, technical processes, travel, waiting and cajolery. A film chews a year out of your life.

Making a paper movie can get one as high as any movie-movie. The processes are similar, without most of the time waste and business junk. You combine the flow of cinema with the contemplative intensity of the still photo. The form pleases.

Of course it doesn't have movement. Or sound. Yet the verbal sound track does give a linear flow. The verbal poetry implies, or, indeed, is, sound. When we read "silently," throat and lips and ears do attend. You might even best use this book by reading its sound track aloud. To yourself or to a friend. Work the words a little for their rhythm and emphasis and roll. You be the director, work for a good reading from your self-narrator. And of course you are the movie projector. The little paper machine you hold is hand operated, you turn the pages.

A paper movie is no substitute, is not less than any movie-movie. It's more than a book of poems. More than a collection of photographs. It's an evolved useful form, originated by such as W. Blake, M. Brady, E. Muybridge, A.Ozenfant, A. MacLeish, A. Malraux, Weegee, W. Morris, W. Evans, E. Steichen, P. Strand, A. Adams, E. Smith. Synergism happens. Something alive can be born of the counterpoint between essential words and images.

Marshal McLuhan ("The Medium Is The Message") has suggested that movies are a "hot" medium, since they bombard our senses with rather complete information as to look, color, movement and sound. Radio, McLuhan says, is a "cool" medium, compelling us to create with our own imaginations. Radio makes us work to conjure up the look and movement of personages, events and ideas.

On this McLuhan thermometer the paper movie might seem to register *warm*. For it's hotted-up radio (with illustrations, with instant playback). And it's cooled-down cinema (contemplative; we can stop the flow and meditate on one image). And it's portable, the paper movie. Infinitely repeatable. Inexpensive. Can be shared anytime with friends. And it's a craft, a form, that can be practiced by almost anybody. Let a thousand paper movies bloom . . .

Technical? If you're interested, most of the photographs in this book were made with a 2¼ by 2¼ Rolleiflex. Other cameras used were a 4 by 5 Speed Graphic, a 4 by 5 view camera, a 2¼ by 2¼ Ikonta B, a Graflex and a Foth-Flex. Do I recommend this equipment? Not necessarily. 35mm is big enough for Cartier-Bresson. The massive 8 by 10 view camera was choice of Edward Weston. Polaroid, anyone? 8mm movies? TV tape?

Poetry is essence. Its creation, and its experience, are a kind of love-making — lifting the heart, energizing the body, enlightening the spirit. Photography too is a very high experience, a poetry, a yoga of the eye. I've come only recently to understand one more reason for photography's power. This is perhaps the ultimate reason. One we've always sensed and not often seen. The very inside of the entirely peeled onion. It is that the stuff the photographer works with, his basic material, is not film or camera or paper or movie screen or eye or even "subject matter." The photographer's basic material is the primal stuff of the universe itself: energy/matter, expressed at its highest vibratory rate, in its "thinest" form (particle *and* wave). The photographer's high and holy material is *Light!*

Would this indicate *(gulp!)* that the photographer's task is nothing less than *enlightenment?*

* * *

7 Fishing boats off St. Croix. *Virgin Islands. 1941.*

9 Lou Stoumen, with family friend Minnie Funk. *Photo by Henry Funk. Springtown, Pa. About 1923.*

11 Samuel Stoumen, MD, and Ford. *Springtown, Pa. Photo by Sarah Stoumen. About 1923.*

13 Sarah Stoumen in her wedding dress. *Photo by D. Perel. Youngstown, Ohio. 1916.*

15 Samuel Stoumen, MD. *1950.*

17 Unemployed men. *Houston Street, New York. 1939.*

19 Young couple in car. *Bethlehem, Pa. About 1940.*

21 Palms. *South coast of Puerto Rico. 1941.*

23 Lou Stoumen shooting with Graflex camera. *Puerto Rico. Photo by Narcisso Dobal. 1941.*

25 Eight frame-enlargement stills from L. Stoumen's first movie, "Tropico," made for U.S. National Youth Administration. *Puerto Rico, 1941.*

27 Boy of San Juan slum "El Fanguito" (the Little Mud). *1941.*

29 Dying girl. *Santurce, PR. 1942.*

31 Church. *Plaza of Juncos, PR. 1942.*

33 Woman and crippled boy wait for elevator. *San Juan, 1942.*